Computer Animation

A WHOLE NEW WORLD

Rockport Publishers
Gloucester, Massachusetts
Distributed by North Light Books
Cincinnati, Ohio

First published in the United States of America by:
Rockport Publishers, Inc.
33 Commercial Street
Gloucester, Massachusetts 01930-5089
Telephone: (978) 282-9590
Facsimile: (978) 283-2742

Distributed to the book trade and art trade in the United States by:
North Light Books, an imprint of
F & W Publications
1507 Dana Avenue
Cincinnati, Ohio 45207
Telephone: (800) 289-0963

Other distribution by:
Rockport Publishers, Inc.
Gloucester, Massachusetts 01930-5089

ISBN 1-56496-377-2

10 9 8 7 6 5 4 3 2 1

Designer: Dutton & Sherman Design
Cover Images: (front) pp. 26, 58
 (back) pp. 115, 130

Printed in HongKong by Midas Printing Limited.

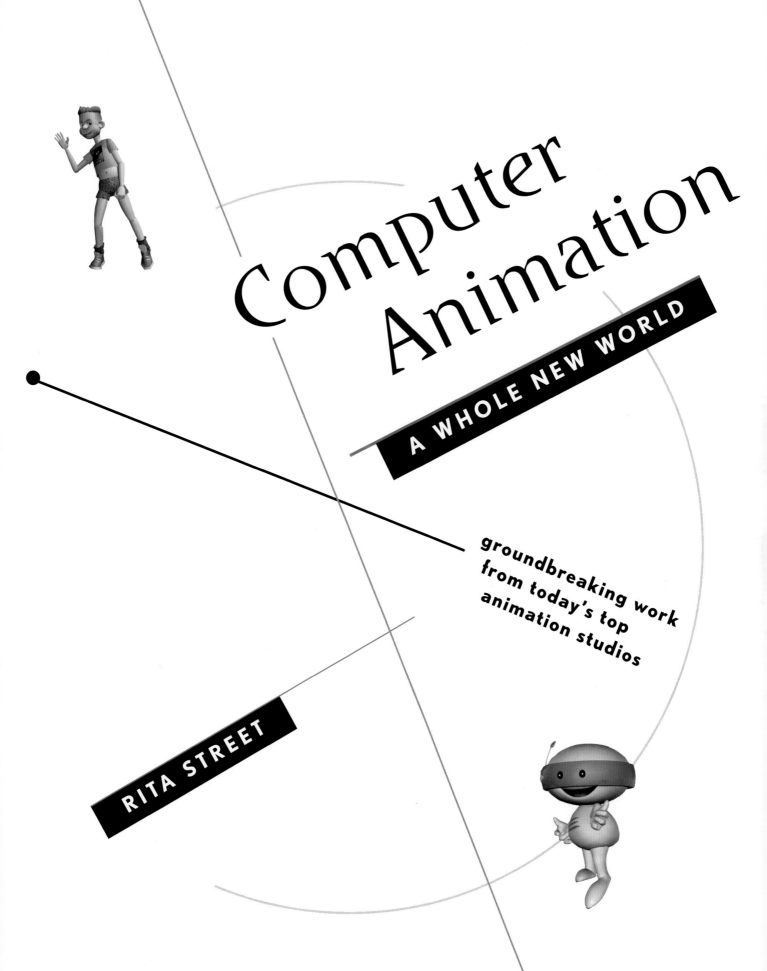

Computer Animation

A WHOLE NEW WORLD

groundbreaking work
from today's top
animation studios

RITA STREET

Contents

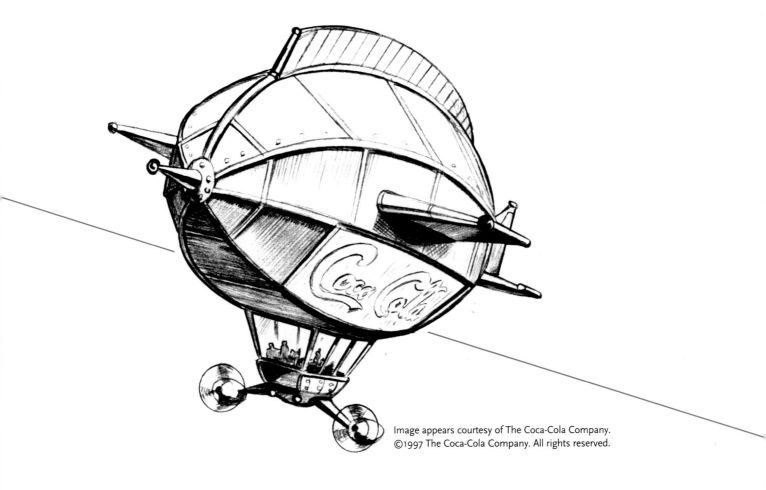

Preface

Nothing moves faster than technology. Conversely, nothing moves slower than the writing and production of a book. So, to publish a book about technology is a bit of a conundrum.

To solve this puzzle, I decided to focus on the artists (and scientists) behind the projects showcased in the pages that follow and the process each went through to bring their art to life. In other words, this is a book about process and passion—and how they coexist while pushing the envelope of technology—not about manual instruction.

Although you will find some great production tips—genuine treasures from some of today's top animators—I hope these pages will serve instead as an inspiration for your own work and an affirmation that anything you can dream you can animate!

Yours, Rita Street

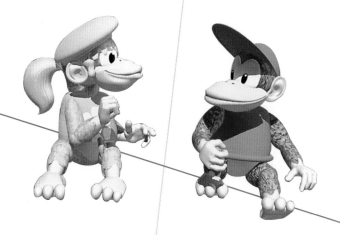

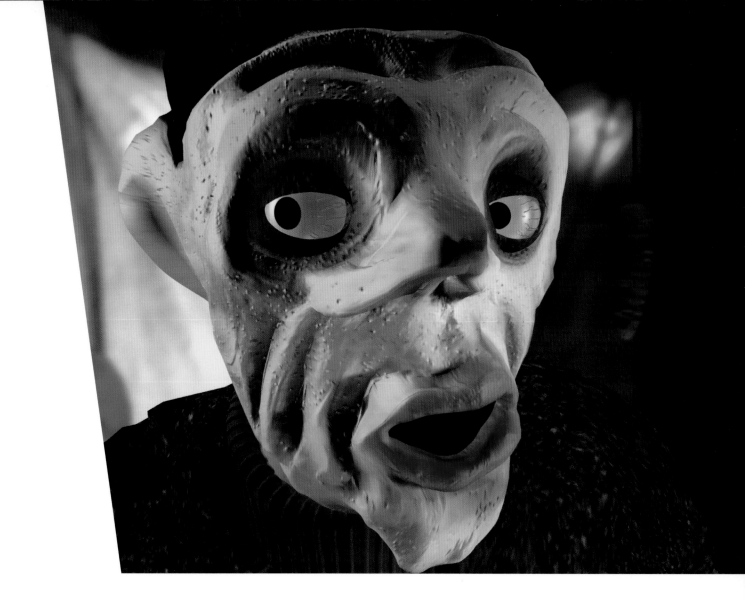

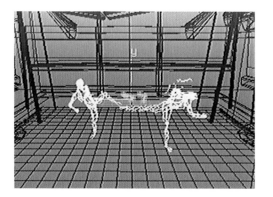

The history of computer animation is only twenty-five years old. In that time artists and scientists have moved from rudimentary flying logos to sophisticated, humanistic motion applied to computer-generated characters.

Ed Catmull, co-founder and executive vice-president of Pixar, the producers of *Toy Story*, the world's first fully computer-animated feature, recounts a brief history of the industry along with the formation of his ground-breaking company.

Introduction

I look back in amazement at the history of computer animation and still find it hard to believe that we could have had such an impact on the entertainment industry. In less than twenty-five years computer graphics has grown from the highly experimental work of a few scientists and engineers at a handful of universities to an art form virtually indispensable to the artistic creation of movies, television series, commercials, and evolving forms of interactive entertainment.

But then, entertainment, specifically the production of a feature-length computer animated motion picture, was always the goal of the artists and engineers who founded Pixar—and, of course, of our pioneering peers. However, our passion for achieving this goal shined ahead of the realities of technology. It took a bit of genius and a lot of work, luck and faith in the future to allow breathing room for science to catch up with the demands of art.

The first milestones came from the University of Utah and the Evans and Sutherland Computer Corporation (E&S). The people there worked on the foundations for rendering images and developed techniques for interactive design. Those early pictures were extremely exciting to us, yet we knew they were crude by the measure of feature films. It was easy to see that we had to be cheaper, faster, and better—but it was not easy to see how we would render complex, rich surfaces. Nor was it easy to see how we could match the lighting that we expect from reality or the motion blur necessary to mix our images with motion picture photography.

Computer animation can envelop you in a totally digital world.

Nevertheless, there were a few groups eager to tackle the problems—and many of those groups crashed and burned because the economics were not right and the imagery not good enough. Such is the fate of pioneers. Yet we all knew that we would achieve our goal if we were just smart enough about it and had perseverance.

The early hardware successes came from Evans and Sutherland who built a great interactive line drawing system that was used in early work. They followed that with the first commercial framebuffer. Here was a device that could hold an entire picture—a new concept for the time, although it did cost $80,000. Today the same capability is included in almost every home computer. On the interactive side, E&S was followed by Silicon Graphics who made interactive graphics an integral part of the workstation and changed the way people worked.

With this new technology, a few companies began to make commercials and special effects for films. This was the burnout lane. Yet some notable commercials and effects were made—resulting in projects such as *Tron, Star Trek,* and *The Last Starfighter.* We had such companies as Digital Productions, Abel, Cranston-Csuri, and Digital Effects. While most of those companies have gone, many of the people went on to form the core of the special effects business.

I went to NYIT after the University of Utah and was fortunate enough to have worked with a very creative group of people. Garland Stern invented a method for coloring 2-D cells for conventional animation that was later used at Hanna Barbera and then at Disney. Alvy Ray Smith and I developed the Alpha Channel and, together with work performed by Tom Porter and Tom Duff later at Lucasfilm, developed the approach that formed the basis for the digital composing work that has so changed the special effects industry. Alvy also wrote paint programs that were extremely influential across the graphics industry.

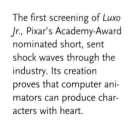

The first screening of *Luxo Jr.,* Pixar's Academy-Award nominated short, sent shock waves through the industry. Its creation proves that computer animators can produce characters with heart.

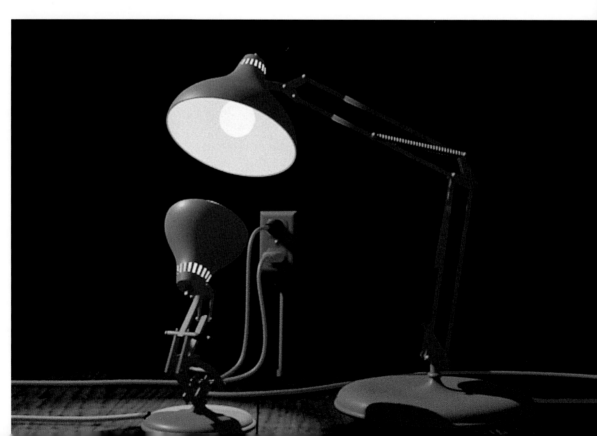

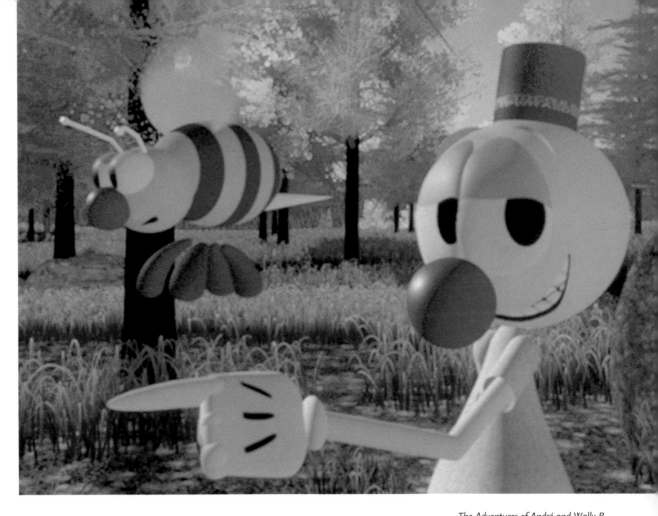

The Adventures of André and Wally B demonstrates Pixar's knowledge of motion blur.

Later at Lucasfilm, we were fortunate to have the backing of George Lucas and were not rushed prematurely into production. We could focus on three important problems: animation control, rendering of extremely complex scenes, and motion blur. Fortunately we were joined by many talented people, such as Loren Carpenter and Rob Cook, who together with Tom Porter came up with an ingenious solution to the motion blur problem. Bill Reeves and Eben Ostby developed an architecture for animation that has lasted all the way from our original shorts through the first feature-length computer animated film. We were also blessed to be joined by John Lasseter, who helped us draw a fine focus on making a system responsive to animators. He also brought a love of story which has shaped the way we work.

Our first project, "The Adventures of André & Wally B," demonstrated our knowledge of motion blur. But our second project, "Luxo Jr.," sent shock waves through the entire industry— to all corners of computer and traditional animation. You see, at that time, most traditional artists were afraid of the computer. They did not realize that the computer was merely a different tool in the artist's kit. Instead, they perceived it as a type of automation that might endanger their jobs. Luckily, this attitude changed dramatically in the early '80s with the use of personal computers in the home. The release of our "Luxo Jr.," a short film created entirely on the computer with enough personality and charm to stand on its own, reinforced this opinion turnaround within the professional community.

Pixar's short films laid the groundwork for the production of *Toy Story*. Here, the Snowman from *Knickknack* tries his best to escape his snow dome.

At about the same time, we completed our first prototype of the Pixar Image Computer. The Image Computer is noteworthy not only because it was the only hardware solution then available that could handle film resolution, but also because its prowess garnered us one of our first big jobs after spinning off to form Pixar in 1986. The creation of the CAPS system for Walt Disney allowed their feature department to scan in every drawing and ink and paint them in the computer. The system's debut came in 1989 with the release of *The Little Mermaid*. A single scene, the finale of the movie with its glorious rainbow, was completed on CAPS. But in Disney's next venture—*The Rescuers Down Under*—every frame went through the computer. This makes *Rescuers* the first CG movie—a little known fact.

Suddenly technology and art were beginning to work together. The second glimmer we all had that the world was about to change came with James Cameron's groundbreaking feature, *The Abyss*, also released in 1989. Cameron and Disney realized that computer graphics was more than just another special effect. This set the stage for the pivotal year of 1991. This was the year that *Beauty and the Beast* and *Terminator II* came out. Both films were smash hits and both made extensive use of computer graphics. Suddenly all of Hollywood jumped on the bandwagon.

Also in 1991 we signed our deal with Disney to make *Toy Story*. Everything we'd been working toward for twenty years rested on the success of this picture. We were very aware that for *Toy Story* to be great, it couldn't be technology driven. In fact, when the reviews came out, we took pride that usually only one sentence was devoted to the fact that this was a computer-animated film—the rest of the copy was devoted to the story.

And that is the glory of working in computer animation today. No longer is art tapping its foot and impatiently waiting on the rigors of technology. Of course, we always want hardware to move faster and software to do more things, but we can make movies now—movies that move people. Engineers work side-by-side with artists and together they create some of the most exhilarating, powerful, and comedic entertainment the world has ever seen.

So while you are enjoying the pages of this book, think back in amazement, as I do, at how far we've come. Then turn your mind's eye toward the future and imagine how far we can go. With animation, anything is possible, even the dream reviews we hope for our second animated feature—in which my colleagues and I imagine reviewers might actually forget to explain that the film was made on the computer—because, while watching it, it simply didn't enter their minds!

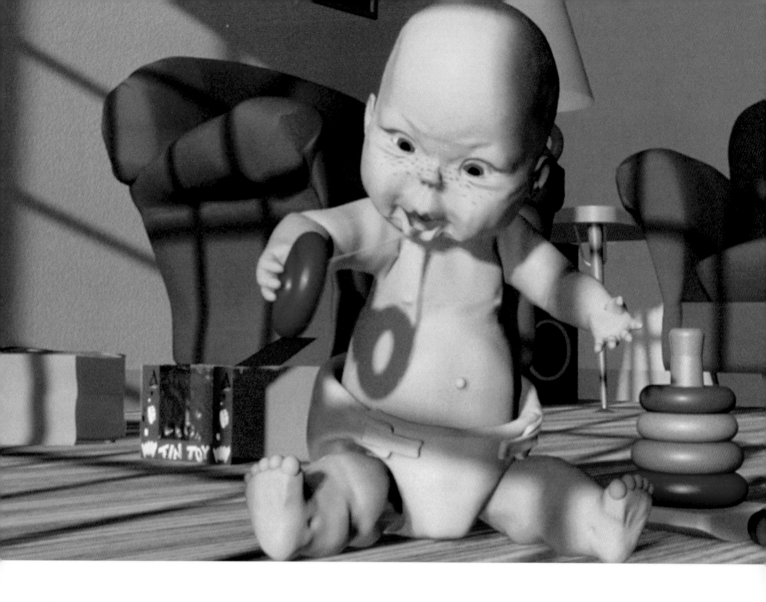

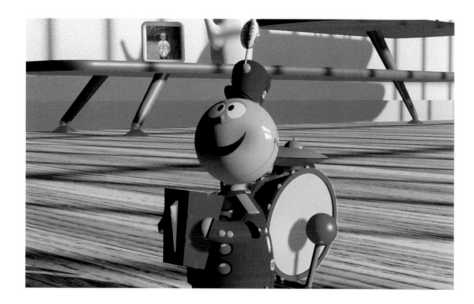

Pixar's *Tin Toy* was the first computer-animated short to win an Academy Award.

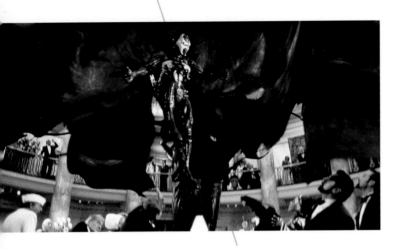

Advances in computer animation make visual effects so compelling that it's hard to believe monsters like the Violator in *Spawn* are make-believe.

The evolution of computer animation has changed the look of feature films forever. Computer-generated visual effects are so refined that viewers find it difficult to tell where reality leaves off and the digital interpretation of reality (or more likely, fantasy) begins. Through computer animation, filmmakers take us to worlds that exist only in the imagination and scare us with aliens we can only hope space explorers will never find.

Feature Film

Bringing Dreams to the Big Screen

This opening section showcases the diverse styles, methods, and creations that computer animators produce for the big screen. But to keep you grounded, we'll first venture back in time to see how computer animation grew up so well, so fast. We'll follow the founders of Pixar as they recount the trials, tribulations, and triumphs of animation production for their famous short films. Each of the five pieces covered led to a groundbreaking step forward in technology and laid the foundation for the company's most amazing accomplishment to date, the completion of the world's first computer-animated feature, *Toy Story*. Next, artists at New Wave International take you on an unforgettable ride through the complex production process of a ride-simulation film. Animators at Industrial Light & Magic shed light on the making of New Line Cinema's cult classic *Spawn*, revealing some of the magic steps behind the integration of live action and visual effects. And finally, two young filmmakers use computers to turn live-action footage into a full-blown Anime-style cartoon.

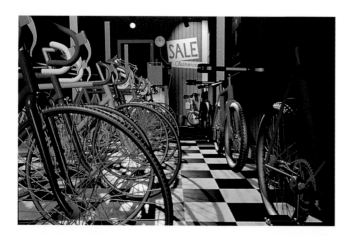

Pixar's famous short *Red's Dream* (top left) proves that computer animators handle moody settings just as well as live-action filmmakers do. They can also transform live action into cartoons as demonstrated by the making of *Plug* (top right). Or—as depicted in the simulation ride *Superstition*—they can take you to the netherworld between life and death (above).

Pixar

Five Amazing Pieces

Walt Disney's *Toy Story*, produced and created by the computer animation studio Pixar, took four years to wind its merry way from story idea to full-fledged silver screen legend. Prior to those four exciting, often grueling years, Pixar artists and scientists put in over a decade of research and development building the many digital tools necessary for Woody and Buzz to take their trip to "infinity and beyond."

Pixar started out as the computer graphics division of Lucasfilm, Ltd. Dedicated to the creation of high-end computer-generated images for effects in feature films, this forty-member team was responsible for the visual effects in *Young Sherlock Holmes, Return of the Jedi,* and *Star Trek II: The Wrath of Khan.* In addition, Pixar scientists created the early high-speed image processor known as the Pixar Image Computer and the Disney 2-D computer animation system called CAPS.

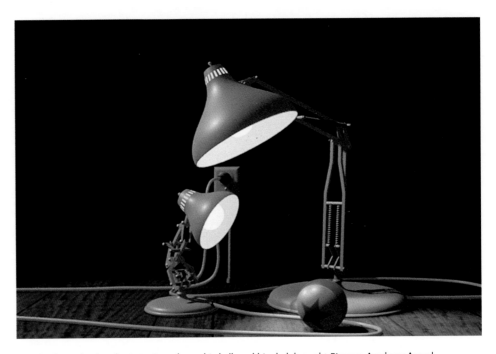

Luxo Jr., the endearing short starring a lamp, his ball, and his dad, brought Pixar an Academy Award nomination in 1986.

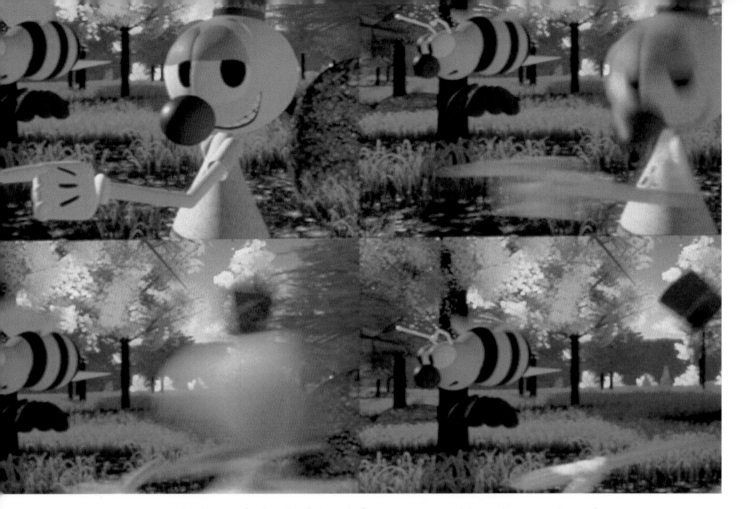

The Adventures of André and Wally B was the first computer-generated short to demonstrate the use of "motion blur."

During the years that the team was associated with LucasFilm and the first few years after they spun off to form their own corporation in 1986, Pixar scientists and artists proved that their proprietary systems actually worked by creating a series of animated shorts. The production of these five screen gems, *The Adventures of André and Wally B, Luxo Jr., Red's Dream, Tin Toy,* and *Knickknack* tested both their developing animation system "Marionette" and the fledgling rendering system, REYES which stands for "Renders Everything You Ever Saw" (later renamed RenderMan™).

But more importantly, these shorts allowed traditionally trained animator John Lasseter (formerly of the Walt Disney company) to flex his "acting" muscles, bringing—for the first time in computer animation history—real characterization to the screen.

Each of the five shorts was created to showcase a particular challenge in the 3-D realm. *The Adventures of André and Wally B* offered the team a chance to test a particle system devised for the "Genesis Demonstration" in *Star Trek II: The Wrath of Kahn.* Says senior technical director Bill Reeves, "We

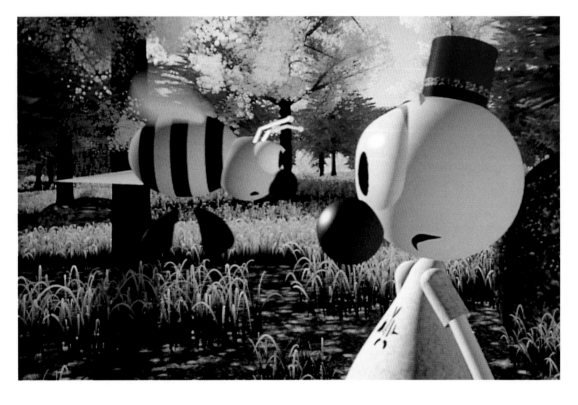

Each of the five shorts were created to show-case a particular challenge in the 3-D realm.

worked on *Star Trek II* in 1981 and that was the first time particle systems were ever used. For *André and Wally B*, I took that technique and turned it on its head."

Particle systems have a stoicastic or random component that allows numerical equations to generate particles that move in an unstructured manner. "The way the particles moved and changed colors in the *Star Trek* sequence, was based on time," explains Reeves. "In *Wally B* they were static and based on spatial relationships. The particles actually became an entire forest with all its thousands and thousands of leaves."

In 1984, when *Wally B* was produced, the polygonal creation of a forest of trees would be so "data heavy" no existing program could render it. The use of a particle system was a unique work-around which allowed for detailed backgrounds but did not take a great deal of disk space to render. However, the use of the particle system did create its own set of challenges. Explains Reeves, "We still had to write a simplified renderer that could deal with that sort of primitive. It definitely took us awhile."

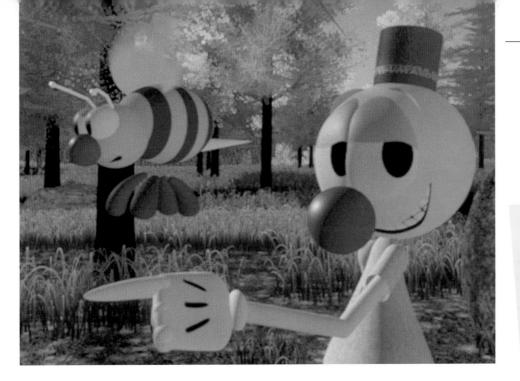

In 1984, when *Wally B* was produced, no existing program could render the polygonal creation of a forest of trees.

Finding machines to render the complex work on the early shorts was a challenge. Often the Pixar team had to rely on donated time. The first Pixar short, *The Adventures of André & Wally B* was rendered on the CRAY supercomputers, the XMP/22 and the XMP/48, courtesy of Cray Research, Inc. MIT's Project Athena donated the use of ten VAX 11/750s from the Digital Equipment Corporation.

The only way to get *The Adventures of André & Wally B* onto tape was to actually film the computer monitor. Says post production coordinator Craig Good, "For our next short we had a laser scanner, but for *Wally B* I had to film each frame. It was a pretty surreal process. It took about two weeks of baby-sitting a rented Mitchell camera, getting only a few hours of sleep each night."

The beautiful, yet stylized forest of *Wally B* is remarkable; its lovely trees with their fall colorings stretch out to the hilly horizon. But what makes the creation of *Wally B* the "missing link" in the evolution from the flying logos of the time to the production of *Toy Story*, was the attention paid to character development. Due to Lasseter's animation skills, the two computer-animated characters show expressions comparable to Mickey Mouse and Donald Duck. Both André, the little wood elf, and Wally, the ornery bee, "react" to each other and portray a wide range of comic emotions.

The biggest challenge for the second short, the Academy Award nominee *Luxo Jr.*, was a self-imposed deadline. Says Deirdre Warin, current computer technology producer for the company, then team receptionist, "Most nights John would sleep in a sleeping bag under his desk and he'd leave a note on my chair to wake him up in the morning so he could get showered and start all over again. That's how much he loved the animation; that's how much they all loved it and still do."

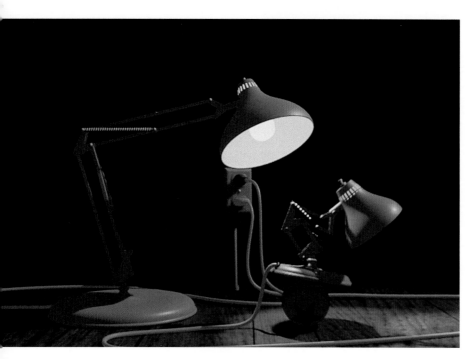

The director of *Toy Story*, John Lasseter, created the digital models of the lamps in *Luxo Jr*. He also gave them their marvelously human-like emotions. As the short opens, a rubber ball rolls up to the Dad lamp, followed closely behind by his son . . .

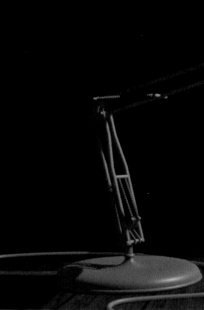

The deadline the team was aiming for was the annual cut-off for entries to the Association of Computing Machinery's "Special Interest Group on Computer Graphics" show, better known as SIGGRAPH. More than just a trade-show, SIGGRAPH is the computer graphics industry's yearly chance to compare notes, give talks on ground-breaking scientific papers, and show off work to peers in the popular "Electronic Theater" screenings. To miss a screening at SIGGRAPH is to be forgotten by the industry for a year.

So the team labored night and day to bring *Luxo* to the convention on time. And, as hoped, the short made it to the show and caused an uproar in the community. Once again the Pixar team brought "character" to the digital realm, while solving a few pesky computing problems that had stymied others.

Luxo began as an animation exercise for Lasseter. Says Craig Good, the team's then post-production coordinator and current lay-out manager, "Lasseter started animating on *Wally B* and picked up the computer really fast. He'd always say he didn't know anything, but we kept telling him he knew a lot more than he thought. In fact *Luxo* started because he wanted to learn how to model. He looked around for something he thought would be challenging and landed on the lamp on his desk. He started off on his own, then got help from Eben Ostby and Bill Reeves. Then we all sort of got involved and it just grew into a short."

Once Lasseter refined the simple story about a little Luxo lamp and its dad playing ball, the team began to focus on the technical challenge of the film—lighting and shadows. Says Ostby, "Our first generation of shading within an animation system was demonstrated in *Return of the Jedi*—the sequence in which the Death Star Hologram appears. Our system was built for that and was enhanced based on John's needs during the making of *Luxo*."

The development of Pixar's shading system, Reeves remembers, was based on a SIGGRAPH paper written by computer graphics guru Lance Williams. Says Reeves, "The genesis of our system was that paper. We really set out to prove that the theories Williams set forth could work. They did work, but the creation process was the implementation of an unending string of details—the setting and resetting of perimeters for algorithms. During *Luxo,* the work on this system never ended."

The beginnings of Pixar's proprietary animation system, "Marionette," also dates back to the creation of *Luxo Jr.* Ostby adds, "None of us had any experience creating an animation system, so we relied completely on what would work best for John. He preferred to have a system that allowed him to 'layer up' his animation. So if Luxo was going to hop, he could start with the gross movement—just the distance he would travel across the desk from the beginning of the hop to the end. Then he could add the top of the hop, then the anticipation of the hop and the follow-through movements. He could just keep adding more and more layers, with each layer corresponding to a control on the model, until the animation worked as a shot."

. . . Baby lamp jumps on top of the ball and, like any little kid, begins to roll happily back and forth. Unfortunately . . .

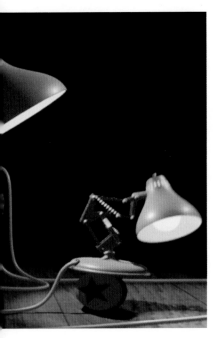

. . . the ball doesn't hold up to this roughhousing and springs a leak. Our little fellow looks up to his father for solace.

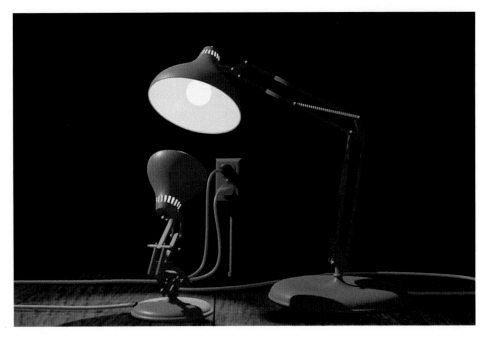

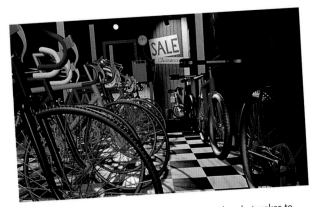

In *Red's Dream*, a unicycle dreams of circus stardom but wakes to find himself still for sale in the lonely half-off section of a bike shop.

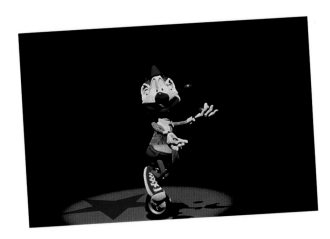

Around the time that *Luxo* was completed, the team, along with Steve Jobs, left to form their own company. The foundation of the new business was hardware design and soon thereafter, software development. But the group that worked to create *Wally B* and *Luxo* stayed together and became the research and development arm of the new company—dedicated now to one thing, learning as much as they could from the creation of short subjects so that the company could soon focus on creating a feature length project.

The third short, *Red's Dream*, was produced to show off the team's ability to convey "mood," in this case a rather sad one. The story of a little unicycle stashed in the half-off corner at the back of a bike shop, *Red's Dream*, portrays the unicycle's dream of starring in a circus act. But on the rainy night of the story, the unicycle wakes to find himself acting out his dream—not in the circus as he had hoped—but alone in a store where nobody cares about him.

The mood is set during the opening and closing shots by a heavy fall of rain on city streets. Using a refined application of the particle system utilized in *Wally B*, Ostby once again turned the tool on its head and literally headed particles "down" toward the ground so that they would appear to be drops of falling rain. The effect of water splashing up as rain-drops hit puddles was created by another particle system triggered by the timing of the falling drops.

Says Ostby, "We worked in a lot of other effects in that short as well, such as lighting and shadows cast by other sources than the sun—colored lights from neon signs and street lights. We also added fog elements."

An updated version of "Marionette" got its first work-out with the production of the fourth Pixar short, *Tin Toy*. This was also the first short to test the company's latest version of the rendering system, now known as RenderMan™. Due to these systems, says Ostby, "We were able to fully articulate complex muscle movements, which was necessary to create the facial and body ges-tures of the baby."

The production of *Tin Toy* pushed the team harder than they had ever worked—once again, all in the name of making SIGGRAPH. Says Ostby, "I didn't even work that hard on *Toy Story*." Yet no matter how many hours the team put in they were unable to meet their deadline.

Says Good, "I'll never forget the tense meeting we had when we decided that we weren't going to make SIGGRAPH. There were very strong opinions on both sides—to kill ourselves and get something, even partially finished, to SIGGRAPH or to just keep going and finish the film period. Ultimately we went with the latter, deciding it was more important to keep our group together than risk what we had going by breaking everybody down."

And the decision, like every decision for this group with the Midas Touch, paid off with an Academy Award in 1988. After that difficult

experience though, the Pixar team decided to take a break and just enjoy the process of making a short rather than continually trying to push the envelope. "We decided that the goal for *Knickknack,* was to have fun," says Ostby. "Of course we did push a few things. We worked with more complex models that had higher levels of animation controls. But we let everyone kind of do their own thing—push their skills in ways that they wanted rather than the short dictated. In fact, everyone working on the film got to animate on it and even model their own characters."

By the time *Knickknack* was in production, Pixar was thriving. Moving away from hardware production into software, it rode on the crest of RenderMan™ sales and the productivity of a newly formed commercial division. Suddenly there was too much work in-house for the R&D team to continue. So its members disbanded, regrouping after a long-term contract with Walt Disney was signed to make three feature-length films. The first of these was, of course, *Toy Story,* the next is called *A Bug's Life* and is due at a theater near you in 1998.

Every toy's favorite person is his baby, at least that's what our hero thinks until he realizes his infant is ready to drown him in slobbery affection.

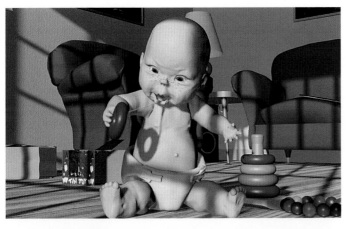

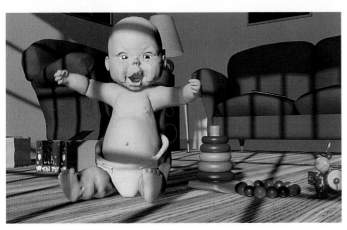

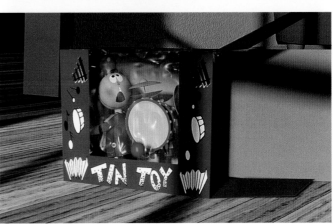

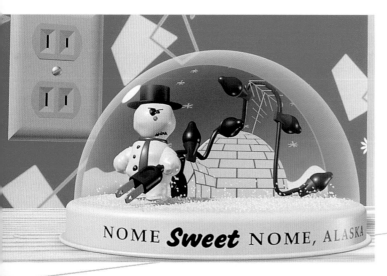
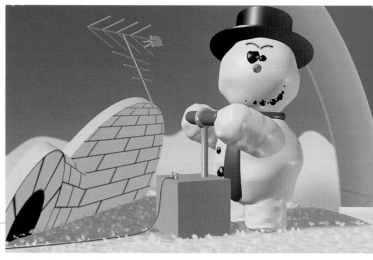
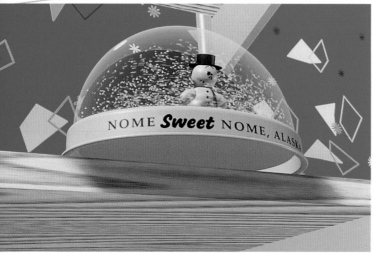
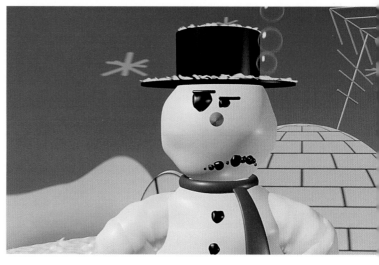

It's a little known fact that *Knickknack* is actually a stereoscopic film.

The Adventures of André & Wally B—1984

Luxo Jr.—1986 (Oscar Nomination, Best Animated Short Film)

Red's Dream—1987

Tin Toy—1988 (Oscar, Best Animated Short Film)

Knickknack—1989

 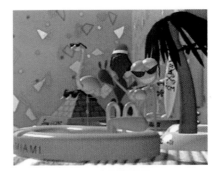

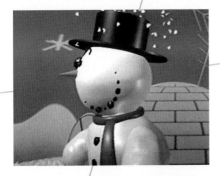 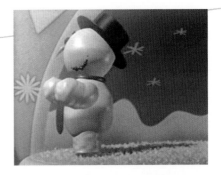

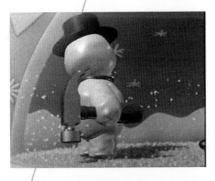 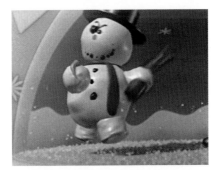 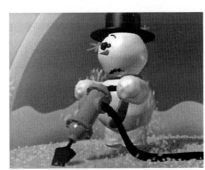

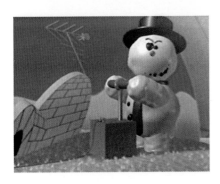

After our hero catches a glimpse of the buxom plastic doll sitting on a "Sunny Miami" ashtray nearby, he is determined to find a way out of his plastic prison. As you can see, his methods become extreme.

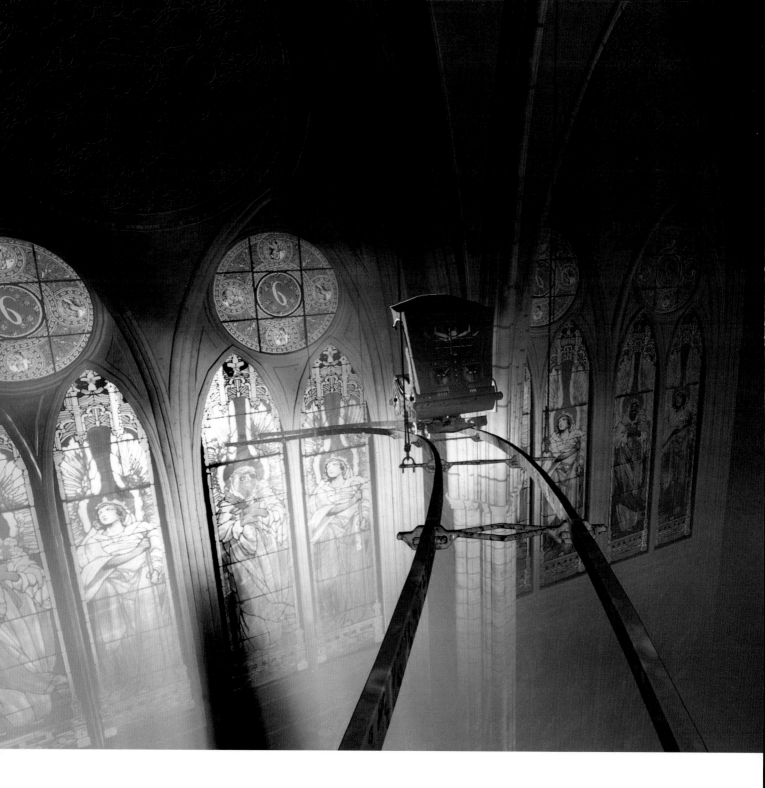

The ride-simulation film, *Superstition*, takes guests through the haunts of an abandoned theme park, an attraction that is definitely not for the faint of heart.

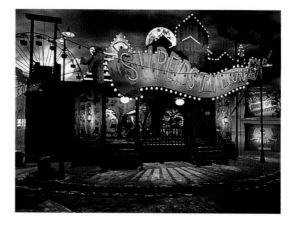

New Wave International
Superstition: The Ride

"Hey! You're like the cat with nine lives. If you've got any left you can always try again!" –Elvira in *Superstition*

"To make a ride-simulation film, we begin by choosing an environment," explains Ben Stassen, president of one of the world's most prestigious (and prolific) ride film production houses. "One that lends itself to the needs of a ride and also one that tends to be dark. The darker the environment, the more hyper-realistic we can make our animation. If the setting is in broad daylight, we have fewer opportunities to work with shadows, the very element that lends credibility to a computer-generated image."

In part that is why the making of *Superstition*, one of New Wave's recent releases was so ideal. Set in an abandoned amusement park, this night-time ride whizzes through some twenty different environments, all related to haunted houses and spooky locales.

"*Superstition* was based on the Stevie Wonder song of the same name. Unfortunately, we were partly through production when we found out that we would be unable to get final clearance to use the song from a third party that owned partial rights. So, we had to improvise," admits Stassen.

But improvisation can be the mother of invention. In the case of *Superstition*, improvisation actually proved to be a lucky charm. Running down the list of possible Halloween icons, he hit upon one of the wackiest—Elvira. The perfect "hostess with the mostest," Stassen brought the "Mistress of the Dark" onboard and incorporated her image into the film.

As the ride opens, we veer past an abandoned carousel and under a huge half-burnt out neon sign that reads "Superstition." This sign is the gateway to the ride and leads us immediately into a dark tunnel. In the distance a pair of cat eyes appear. But as they quickly approach, they melt into the headlights of Elvira's ride car. "Welcome, darling. I've been expecting you. Let's see, I'm in car number twelve. That means you must be in car number thirteen. Better cross your fingers . . . and your toes!" she says as her car zips down the tunnel leading us into a terrifying haunted house and the plethora of exotic environments to come.

To meld Elvira's image into the computer animated world of *Superstition*, she was filmed against a green screen and then composited into pre-existing digital creations. But, like everything in large format, this was not your typical green-screen shoot. Explains Stassen, "This was definitely not a simple composite shot. Elvira had to appear to be riding in a car in front of the viewer that rotates to the right and left and moves backwards and forwards. So we put her on a seat on top of a turntable. Grips spun the turntable in sync with a monitor that displayed the movement of the digital car she would be sitting in."

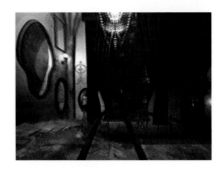

The walls of this haunted house drip with eerie images of Elvira. Even the fantastically detailed carpet looks like it's coming to life.

From New Wave's *Secrets of the Lost Temple.*

With the speed of computer hardware increasing exponentially, it doesn't seem possible that it takes 20,000 hours to render one four-and-one-half minute film. But such is the case if you are making computer animated motion-simulator ride films for Showscan (a 70mm format that projects sixty frames per second) or IMAX (a 70mm format that runs horizontally through a projector increasing the size of the image to the height of a five-story building).

Large format filmmaking is hardware intensive and unforgiving to the computer-generated image. Says Ben Stassen, president of New Wave, "Our images are projected on such large screens that any lack of detail, any minuscule flaw, is magnified a hundredfold. If something is left to chance, some highlight or shadow that looked right on the computer monitor but doesn't hold up on film—it will destroy the illusion for the audience."

Says Stassen, "I always wanted to make films that are seen by the large audiences that a major studio can generate. However, I was never so naive as to think that I could produce the next *Terminator* without studio backing. But, then the desktop computer workstation came into being and suddenly it was possible to make something really spectacular with a relatively small amount of financing, some hardware and a few talented artists. For me, the desktop computer workstation is a mini-Hollywood studio."

Devil's Mine Ride, Stassen's first production, has been seen by more than 25 million people worldwide.

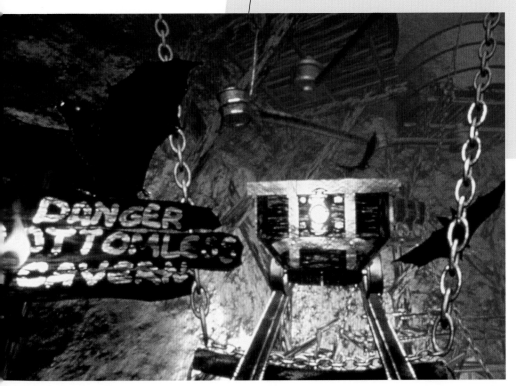

The Showscan Entertainment film, *Devil's Mine Ride,* was New Wave's first production.

After a hand-drawn map of a ride is created, a set of digital tracks is created in Wavefront Explorer software.

In addition to the timing of the dark princess's movements, the live-action crew had to create interactive lighting to match the lighting within the digital world of *Superstition*.

"For the most part this worked well," explains Stassen. "Elvira appears in five shots and all but one composited cleanly into the ride. The other we had to re-animate."

But re-animating a scene in a New Wave ride film is not a simple process. Unlike many ride films, New Wave productions never cut away to enter a new environment. "Our films are the equivalent of a long establishing shot in live action. If an actor drops a line or a grip drops a flag into the camera's line of sight, you have to redo the entire scene," explains Stassen. "It's the same with our work. If we make a change, we basically have to redo everything." That is why so much attention is paid in the beginning of the process to the "map" of the ride.

Once the environment is established, an artist actually draws out the entire plan for the ride, a plan that taps into the human psyche's primal craving for excitement. Says producer Charlotte Huggins, "In a way, a ride film is sort of like a good movie. It has a build up and a main body and then just when you think it's over, when you think you're safe, there is one last thrill."

Ray Spencer, who has mapped numerous rides for New Wave, starts out with a simple sketch. "Part of the process," he says, "is just setting pencil to paper. For me it's almost stream of consciousness once I start making my chicken scratches. I know going in approximately how many environments I need to establish, so I just sort of let my mind flow from one to another."

Spencer notes that he is always careful to establish credibility at the beginning of the ride for the viewer. Since ride films are fast paced, it can be difficult for a viewer to take in everything if they are not prepped in the first few seconds with enough visual clues — clues from objects or even a narrator that tell them exactly where they are and what they are about to experience.

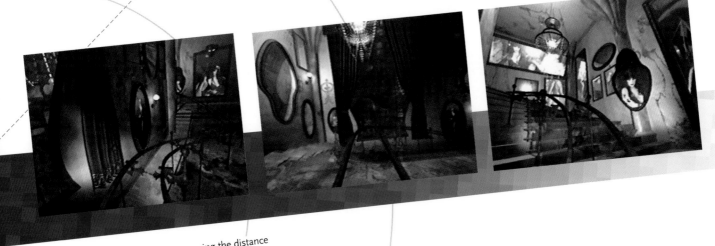

The feel of speed is created by varying the distance between the tracks and the surrounding environments. The closer the walls appear, the faster the ride seems to go.

This clip from *Thrill Ride—The Science of Fun* shows the difference in film formats. The postage stamp-size image is 35mm. The larger image is 15 perf/70mm.

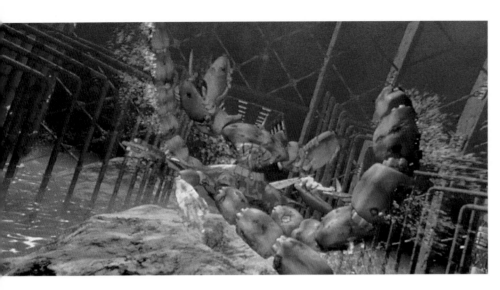

In New Wave's *RGB Adventure*, an evil warlord tries to steal the colors of the rainbow from poor innocent planet Earth. The rider saves the day, but along the way has to do battle with creatures like this from the dominion of Blue.

©ACC Productions
Creative Studio

The animation for New Wave rides is produced at its two Belgium-based studios: Movida and Trix. The animation team uses the ride-map as a base to begin their work. Using Wavefront Explorer software, an animator begins by building a simple set of tracks that follow the path of the map. Says Stassen, "The digital camera moves are established at this point to follow the tracks. After we have recreated the map to the best of our ability in the computer, we build a black box around the tracks that simulates the high-resolution environment of the ride. With the addition of walls, you start to get a sense of the pace of the ride. If the tracks are passing through a wide open space, it may not seem like we are going very fast. However, if the walls are close in to the tracks it will seem like we are going at an incredible rate."

Once the timing for the ride is figured out, the animators begin to layer in background and foreground elements. With the addition of each new element or animated object, the timing must be adjusted.

The final step in the creation of a New Wave ride film is the rendering process. Says Stassen, "Because we can do more now, due to improvements in hardware speed, it's taking us longer and

A chamber of mirrors in *Superstition*.

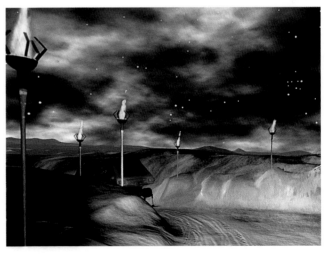

Glacier Run takes guests on a high-tech high-speed bobsled ride in an imaginary arctic realm.

"One of the biggest challenges in animating a ride film is the issue of strobing. Strobing occurs when the amount an image moves between frames becomes too great. When this happens the image appears to jump. And if this happens for more than a few seconds, it can really make you sick. Strobing occurs most often when the camera moves quickly to the right or left. Ideally your camera should be stationary, but ours are always on the move. What we do, is try to avoid as many 'naturalistic' moves as we can. When our camera moves to the right or left, it will do so in an unusual, surrealistic fashion."—Ben Stassen

New Wave films never cut away to enter a new environment. Like a long "establishing shot" in live action, each scene moves seamlessly into the next.

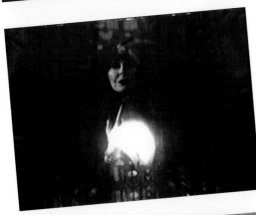

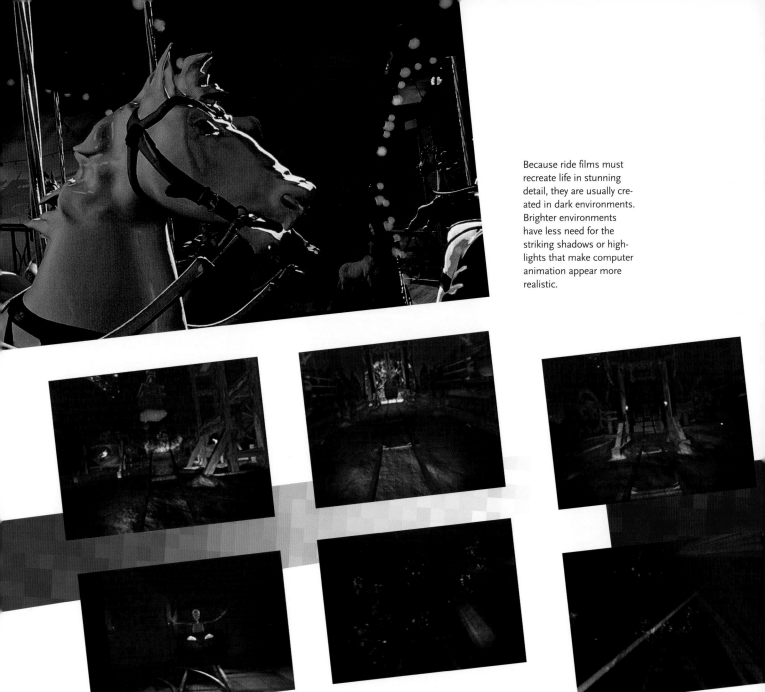

Because ride films must recreate life in stunning detail, they are usually created in dark environments. Brighter environments have less need for the striking shadows or highlights that make computer animation appear more realistic.

longer to render our animations. When we produced our first film, *Devil's Mine Ride*, one frame took about a half hour to render. For *Superstition*, because our frames are much more complex, it took almost an hour to render a single frame."

After the film is rendered it can be output for use in any format. Says Huggins, "There are a half dozen formats with a half dozen different frame rates. If you shoot your film as live action, you can't reformat very easily. Every time you do you lose a generation. Because we always stay digital and produce our films for the largest aspect ratio in the highest resolution, all we have to do to provide a new print in a different format is run an algorithm program on it, output it and ship it off."

New Wave International's latest film is a fifteen perf 70mm documentary on the history of roller coasters and motion simulation called *Thrill Ride: The Science of Fun*. According to New Wave producer and C.O.O. Charlotte Huggins, this breathtaking tribute includes "a historical look at roller coasters and the physics of why they work . . . and don't work. The origins of motion-based rides—those being aerospace simulators—and the emerging genre of the motion ride itself." *Thrill Ride*, which includes a behind-the-scenes look at the making of many of New Wave's own rides, is guaranteed to knock your socks off.

With IMAX and other large formats such as Iwerks investing in theaters attached to multiplexes, you'll find it easier and easier to catch a ride on a New Wave film. When you do, enjoy. But, remember, as Elvira would say, "You'd better have nine lives if you plan to survive!"

To create the stained glass window in *Superstition* animators found slide images of a real cathedral window and used these both as reference and as live-action elements. First they scanned the slides and brought them into a computer paint program. There the images of glass were manipulated and then used to create texture maps that could be applied to the window frames in the ride backgrounds.

Since the team wanted light to fall through the glass, they also needed a way to recreate the many refractions that occur when light passes through colored glass. For this, they simply projected the slides and filmed the colored light that the projection created, then composited these "light" elements into the foreground.

Every New Wave film starts out with a detailed map. This one helped animators create the complicated world of a child's bedroom.

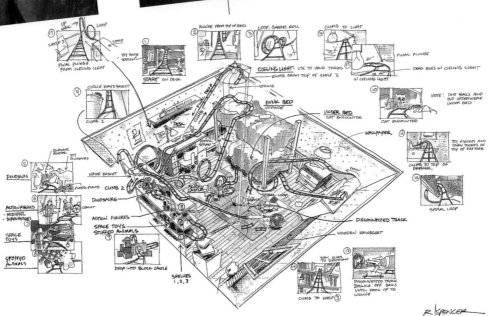

KID COASTER

MOTION SIMULATION RIDE CONCEPT

© NEW WAVE INTERNATIONAL

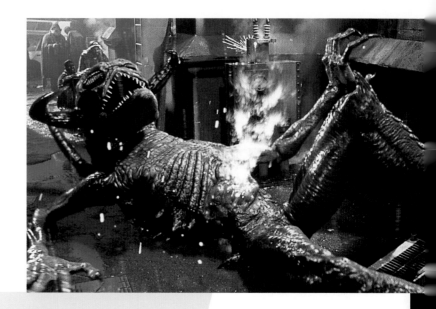

"We created three categories of goo. One was for the slime that oozed out of the bodies when they were stabbed or pierced. The other was a kind of gaseous Hell Fire that blows out of the demons' bodies if they are wounded. And the last was the saliva that comes out of Violator's mouth," says associate special effects supervisor Habib Zargarpour. The various forms of goo were created using a blobby tool, which looks, according to visual effects supervisor Steve Williams, like, "a bathtub full of color ball bearings on your monitor. To get these ball bearings to look like goo, you make them cling together like frog eggs and then animate them, applying elements like gravity and wind to give them a realistic touch."

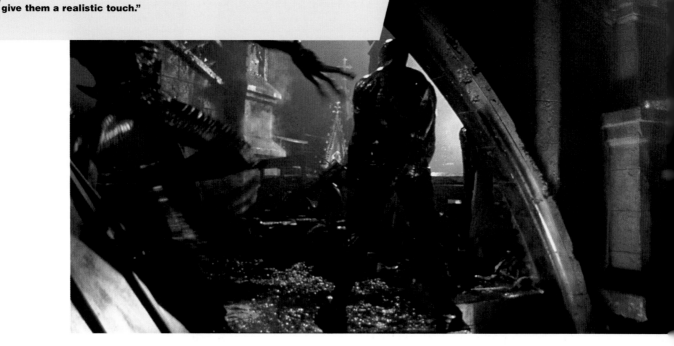

"Spawn" copyright 1997, New Line Productions, Inc. All rights reserved. Photos by Industrial Light and Magic. Photos appear courtesy of New Line Productions, Inc.

Industrial Light & Magic

Spawn

The animators at Industrial Light & Magic (ILM) get some pretty "out-there" challenges thrown their way. They've made dinosaurs walk and roar for *Jurassic Park*, Draco the dragon fly in *Dragonheart*, and tornadoes wreak havoc in *Twister*. But, of all their tasks to date, nothing is as strikingly edgy as the animation they've created for *Spawn* (a New Line Cinema Release).

The story of secret agent Al Simmons who makes a pact with Malebolgia, the Master of Hell, that backfires (Simmons becomes Malebolgia's main man, his Hellspawn and the leader of the armies of Hell), *Spawn* is an action-adventure that makes the dark style of the *Batman* features look "homey."

Compared to *Jurassic Park*, *Spawn* was a fairly small project for ILM. But that didn't mean that the artists weren't gung-ho. Unlike the specialization necessary for large teams assigned to a megabudget movie (for

Zargarpour started work on the velvety cape texture with an in-house 3-D paint program. Additional glimmer was added in the RenderMan™ shader.

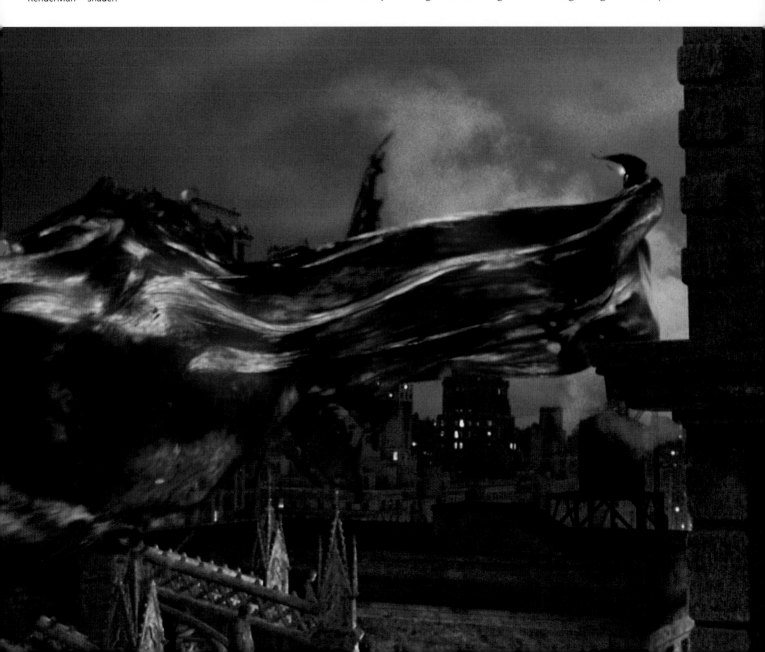

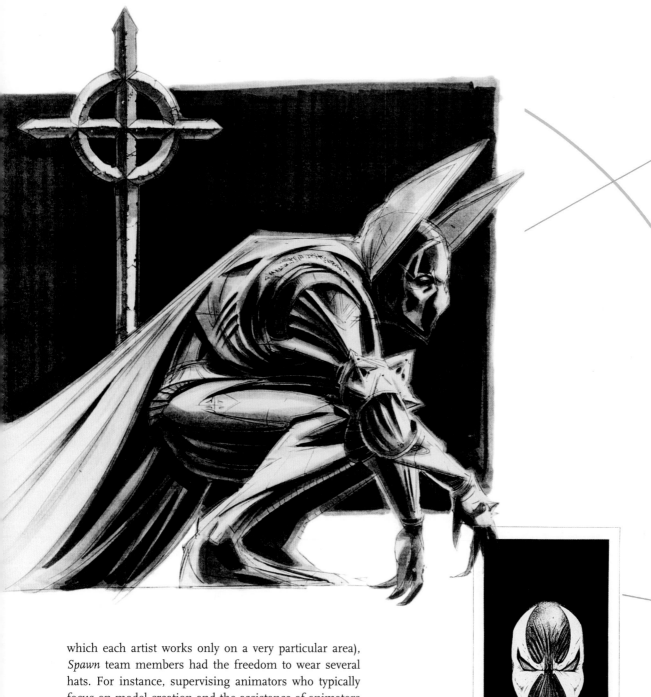

which each artist works only on a very particular area), *Spawn* team members had the freedom to wear several hats. For instance, supervising animators who typically focus on model creation and the assistance of animators with technical issues had time to sneak in a little animation.

Work on *Spawn* began in the modeling department. The two main character models, those of Spawn and his nemesis Clown, were created first. "Once the model was digitally sculpted," says animation supervisor Dennis Turner, "my job was to add controls or 'chain' the model. When you chain a model your biggest problem is making sure that it doesn't interpenetrate itself. In other words, you have to make sure that a joint doesn't penetrate

(Above left) The inclusion of a cross in the piece of conceptual art hints at the torturous choice Spawn most make between good and evil.
(Above) A drawing of the living facial armor that emerges to protect Spawn when he calls it by thought.

Explains visual effects supervisor Steve Williams, "To create the cape we began by modeling its basic form in b-spline patches, which made it look like a four-sided bed sheet. We could have animated all four of those points by hand to make the drapery of the cape believable, but it was simpler to use a program that mimics effects in nature—like wind or gravity. The program we used is Dynamation, a plug-in for Alias/Wavefront."

Associate visual effects Supervisor Habib Zargarpour says, "Dynamation allows the user to add his own 'clip effects,' which are groupings of lines of code that create physics equations along with buttons or sliders within the software."

Artist Julia Learie was one of the animators responsible for the movement of the cape. Her primary scene was an action-packed sequence involving a motorcycle. Explains Learie, "In this shot, Spawn is riding a motorcycle and his cape shoots out of his back and flows behind him. It then creeps forward and forms a protective shell around Spawn and the motorcycle."

Learie began by modeling half of the shell. She then duplicated and inverted this model to create the other half. "After I'd created the shell, I worked on the animation inside our proprietary software, pulling and stretching the geometric shapes of the cape around so that they appeared to be flapping in the wind behind the motorcycle. Next I started to form the pieces of the cape into big chunky shapes that would turn into the shell."

After Learie had the timing she wanted for her animation, she turned the scene over to Zargarpour who added the dynamics of wind effect, which enabled the small folds of the fabric to move in realistic manners. "Getting something like this right," says Zargarpour, "is a really collaborative process. The animator will work on the broad strokes. Then I'll add detail. So we end up doing a lot of back and forth before we get something we both like."

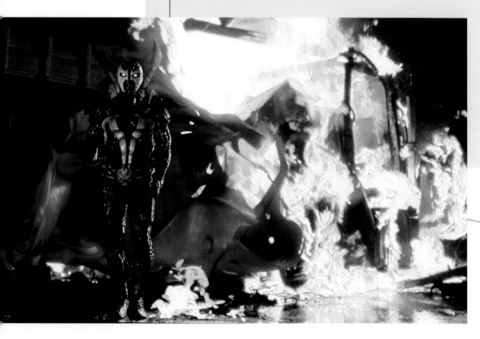

An entirely digital Spawn emerges from the flames.

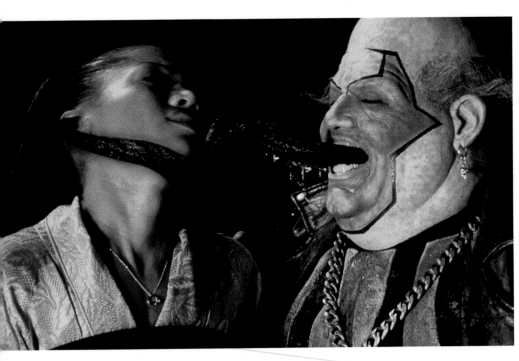

Clown indulges in a taste of Spawn's
true love, Wanda.

through a socket. With Spawn this was really tricky because he's such a beefy guy. His arms were so big that they were constantly sticking through his chest. So I really had to play with the enveloping (the way the patches, which represent muscle groups, work with the movement of a model's skeleton), distorting shapes so they look as if they're actually touching and creating algorithms so that the various parts could detect each other." A brand new piece of technology was incorporated that had to do with muscle movement. Explains associate visual effects supervisor Habib Zargarpour, "Before if we wanted to get the deformed look of muscles, we had to grab patches and animate them. Now we can position patches so that they appear to be muscles underneath an actual layer of skin."

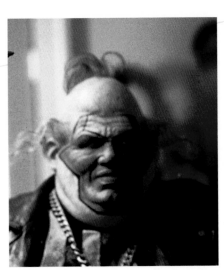

The Clown is played by
actor John Leguizamo.

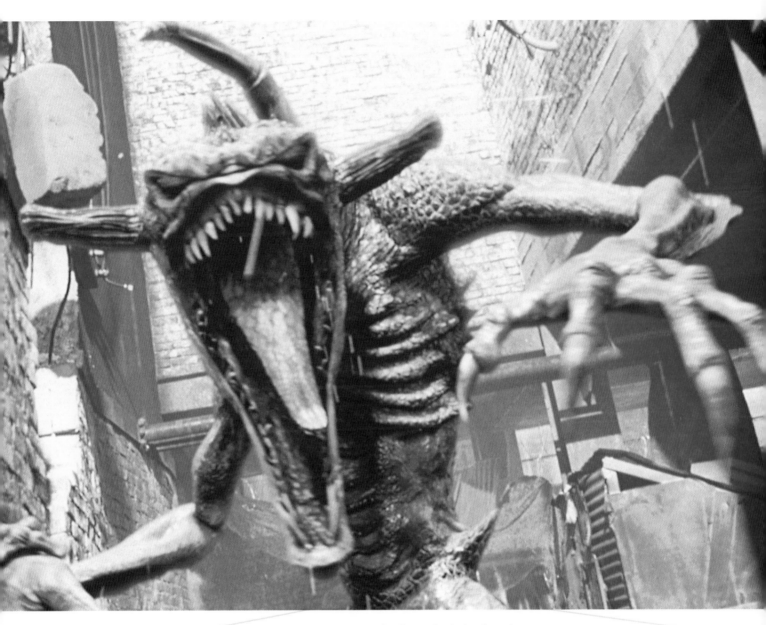

The Clown unleashed as the Violator

The Clown/Violator character was much simpler. (Clown is a demon that disguises himself as a bizarre homeless circus freak. His job is to incite Spawn into action, convincing him through trickery, that he must forget his heart and fully become the leader of Malebolgia's dark army. To do this, he transforms into his "better half," the Violator—a twelve-foot-tall reptilian nightmare.) The Clown model was based on the fat suit created for John Leguizamo, the actor who plays the live-action character. The Violator portion of the character mirrored the structure and detail of his animatronic live-action twin, created by creature shop KNB. For some sequences, the animation of *Spawn* was created through motion capture. This was not true, however, of Violator. No matter how talented the actor, no human being could move anything like the twelve-foot-tall insectoid.

41

ILM artist Scott Leberecht was responsible for creating the initial visualizations of Clown's transformation into Violator. The main thing he tried to avoid in his artwork was a morph, or wipe. Says Leberecht, "I wanted to create something much more interesting. So rather than have everything sort of ramp-up and change all at the same time, I had different parts do different things at different times."

The unfolding and transformation of Spawn's cape into armor was another challenge for Leberecht who decided to approach it in sections. "I was always fighting the problem of trying to keep the cape from looking rubbery or mushy when it transforms into armor. So I made it unfold like a Transformer, part-by-part, sort of like cutting it up into puzzle pieces and then putting them back together."

Associate visual effects supervisor Habib Zargarpour explains how the texture of Spawn's cape was achieved: "Artist Rebecca Petrulli created a lot of the texture maps for *Spawn* using our in-house 3-D paint software. For the cape, I went for a velvety look. To get this, I started with Rebecca's base colors over a static model. Then I added variations to the color along with bump and specular maps. Then I took the entire model and all its elements into our RenderMan™ shader and, using fractal and noise functions, I was able to get a sort of additional glimmer on top of the velvety sheen I was going for."

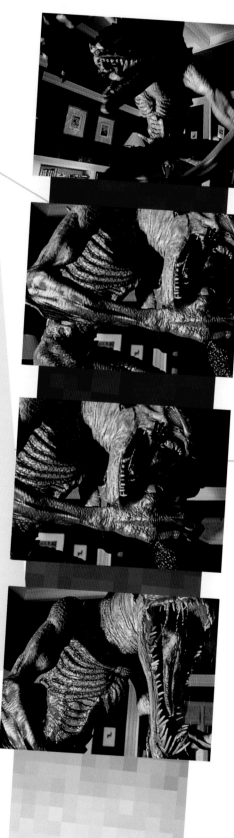

The denizens of Hell can be destroyed only if their heads are severed from their bodies. Here Violator returns unexpectedly in a manic effort to decapitate Spawn.

Developing the transformation between Clown and Violator took a little doing. Says Turner, "I used sketches from our art department that mapped out the transformation as my guide. Then I relied on my own acting ability to help me think the transformation through. I knew I wanted it to happen in quick staccato stages, so it would show that this is painful for Clown. Based on that, I acted out the moves and timed myself with a stopwatch. I made thumbnail sketches of the major movements and matched those up to my timing. Then I started recreating that outline in the computer."

The most difficult part of the transformation, adds Turner, was the extreme variations between the two body shapes. "They have radically different proportions. Clown is a little fat guy and Violator is a twelve-foot-tall monster. Nothing about them is similar, except that they each have a head, a torso, and two legs. Everything else is different, even down to their feet. Clown wears big silly clown shoes and Violator has huge toes. Since nothing was the same, I started by fitting Clown inside Violator. Then I changed the shape of Violator until he fit the general silhouette of Clown."

Clown has just transformed into his Hellish-self, a twelve-foot-tall reptilian monstrosity.

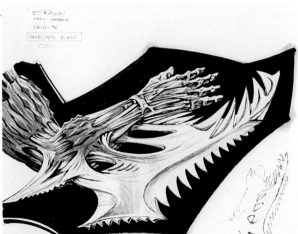

Spawn's living armor transforms into fantastic weapons at a thought's bidding.

43

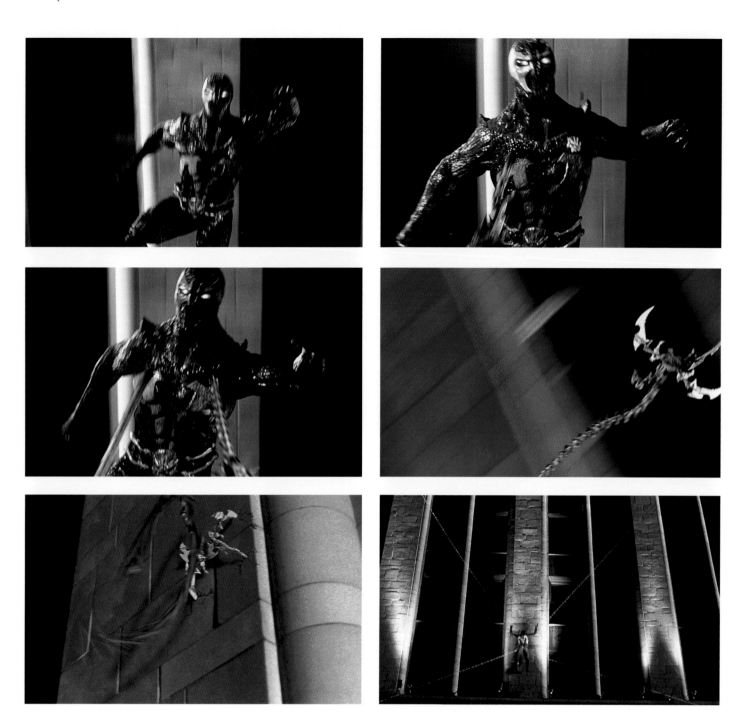

Spawn's grappling hooks
and chains snap out from
his body, dig into con-
crete, and break his fall.

In addition to his cape Spawn also has an arsenal of weapons that appear as needed. His arm, for instance, can morph into a striking weapon. Or chains can emerge from out of his belly. Animator Scott "Huck" Wirtz and technical director Greg Killmaster were responsible for one of these "chain" sequences.

Says Wirtz, "As Spawn falls off the side of a building, the chains come out to save him. I wanted to make the chains look like they were alive, so I made them very snakelike. Of course, this is all happening very fast because he is falling, but I think the sense that they are alive gets across."

Wirtz animated the chains with low-resolution stand-ins that looked a lot like plastic tubing. The sequence moved down the production pipeline to Killmaster who added "instancing," which is a repeating pattern that made the tubes look like they were linked chains. Killmaster added little extras to make the scene look even more realistic, like the links "flipping over and over" as they move out to grab the wall.

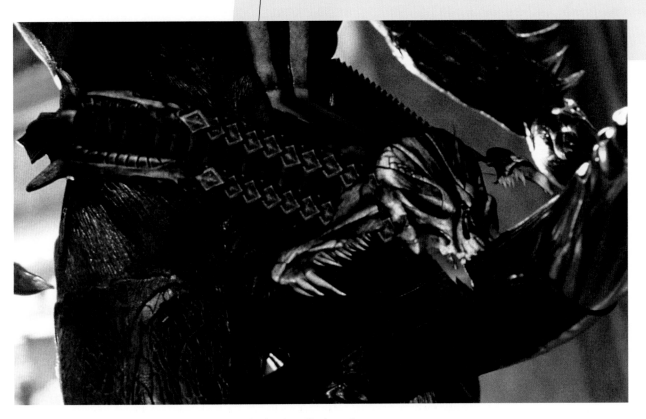

Quicker than his own reflexes, Spawn's body armor attacks the shin of his booted female nemesis and ex-peer, Jessica Parker.

Once the models were created, the animation team was almost ready to go. But before the animators received their scenes, the live-action film was scanned and sent to the "match-movers"—a team that places models in their correct beginning location within a live-action frame. Technical directors also supplied the animators with camera moves and basic lighting. At ILM, animators are typically responsible only for the art of the movement of a character. Everything else is completed by another team of specialists. However, on *Spawn* animators were sometimes responsible for their own "match moves."

When an animator begins, he or she works with a low resolution stand-in of the completely rendered model. "We start out by blocking in the basic movements, getting a rough idea of the pacing and action of a scene," explains senior animator Tim Harrington. "Then we send that along to a technical director who runs the scene overnight—compositing it into the live-action background. Then we all take a look at the work—with the animation supervisor and visual effects director—the next morning. They give direction and you start the process all over again, adding layer upon layer of animation, until you come up with the final product."

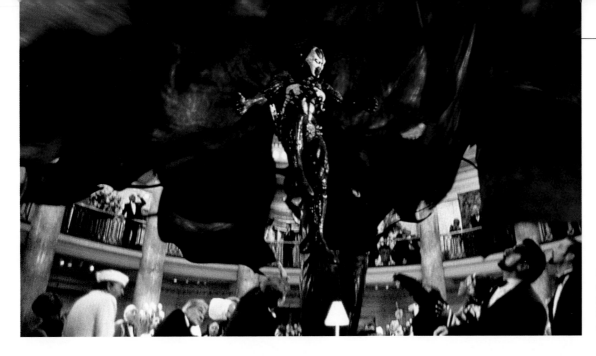

Spawn makes a dramatic entrance, interrupting a reception in order to kill his former boss and arch-enemy, Jason Wynn.

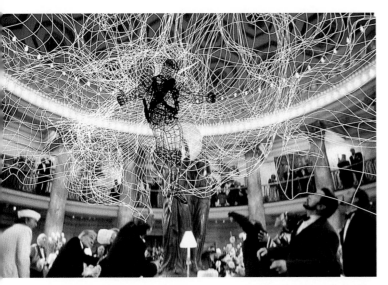

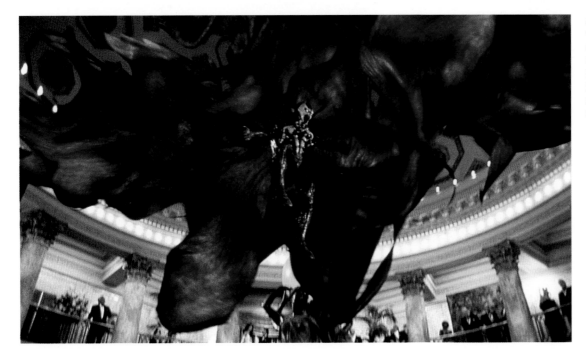

Associate visual effects supervisor Habib Zargarpour works on the cape's magnificent movement, making it unfold in a series of dramatic transformations—much like a fast-motion view of a garden of rosebuds opening.

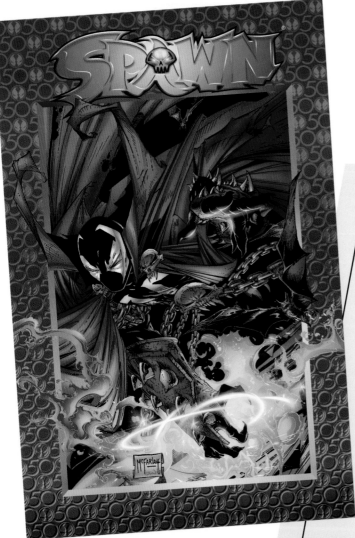

Trademark™ and ©1996
Todd MacFarlane
Productions, Inc.

Todd MacFarlane created *Spawn* in 1979, but it sat in a portfolio for twelve years until MacFarlane, a popular comic book artist and writer, joined a group of his artist pals to form Image Comics—now one of the most powerful publishers in the world. Says MacFarlane, "I'd always liked Spawn, so at that point I started to really work on his backstory. The easiest way to do that was to base everything on my own belief system—how would I react if I was having this experience?"

But Spawn's experience is far from normal. (Then again, so is MacFarlane's. Not every great comic book artist makes more than $75 million on one idea.) Spawn was once Al Simmons, a member of a top secret assault agency. But his boss had him killed when he started questioning the ethics of company policy.

As Simmons is dying, Malebolgia, the Master of Hell, steps in and makes Simmons an offer: in exchange for the powers of Hell (that Simmons can use to revenge his death and see the woman he loves), Simmons must lead Malebolgia's dark army to destroy the Earth.

But Simmons is spiritually unable to do Malebolgia's dirty work, even though he is goaded into it by the Violator. Also, his ex-boss has planted biological weapons in the major cities of the world, all set to blow if his heartbeat stops. So Spawn must find a way to save his loved ones and break his pact with Hell.

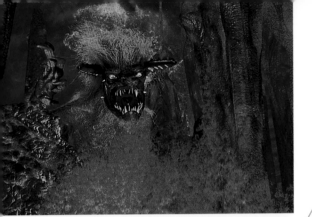

Malebolgia, master of hell, is on the attack.

The climax to *Spawn* is three minutes inside the eighth level of Hell—every second of which was digitally created. Says first-time director and former ILM effects veteran Mark Dippe, "I didn't want to make Hell another version of Dante's Inferno. I wanted a much more metaphorical look that concentrates everything on this last battle—the metaphor being the descent into the belly of the beast. It's a dangerous, wild place, where spirits are trapped and everything is complete chaos. There is fire, but not the kind you find in your fireplace—another kind that moves sideways, bubbles like plasma and erupts. So of course we used a lot of particle systems in the animation. It was all really ambitious, especially since in addition to the beast metaphor I wanted to create the illusion of endless space—like this place goes on forever and ever."

USC Film School

Plug

The Flying Machine design is based on
the Bayou Boats of Gentle Ben fame.

The granddaddy of all film schools is located on the University of Southern California campus. Producing such stellar alums as George Lucas and Robert Zemeckis, the USC School of Cinema–Television is "the" place to begin a career in Hollywood. Not only is the training top notch, but the connections students make (between each other and alums) open post-graduate doors for them in Tinsel Town.

However, the majority of would-be filmmakers come to USC to make the next *Forrest Gump*, not the next *Toy Story*. A fact that makes the production of *Plug*, a seven-minute short in which every frame was digitally scanned and manipulated using a custom-made computer animation program, a bit of an oddity.

Says director Meher Gourjian, "We were definitely the lunatic fringe of USC. Everybody who goes there wants to make a 16mm live-action movie. So the MFA animation group sort of gets stuck in the basement."

However even the basement of USC, which happens to be a fully outfitted computer laboratory, is a virtual filmmakers' nursery. For Gourjian and partner/producer Jamie Waese (the two outgoing young men determined to make their thesis project something their film school had never seen before), it was nothing less than a gold mine.

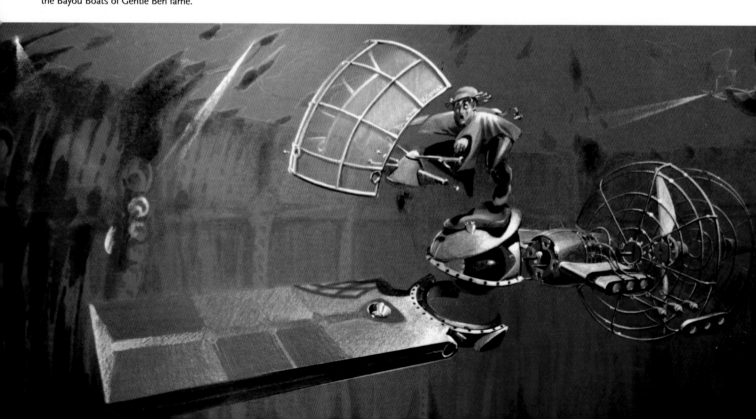

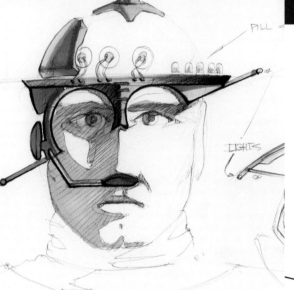

Plugworld inhabitants struggle to maintain a physical connection between outlet towers and the extension cords they carry in portable backpacks that hook into their brainstems. When they're not "plugged" in, reality changes form.

Previsualization backgrounds show a world devoid of human comforts.

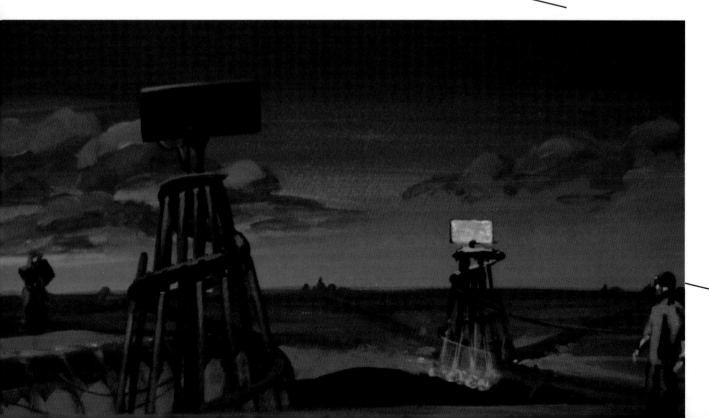

51

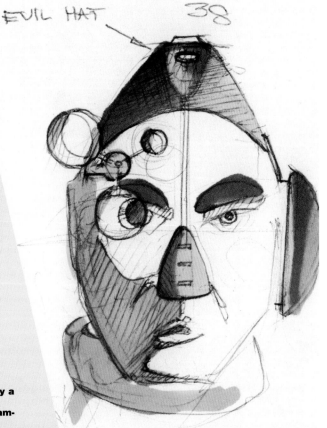

EVIL HAT 38

DONATIONS

"If somebody were to say, 'Guys, I'd like you to make this film exactly as you've made it only without your student cards,' it would cost about $370,000," says producer Jamie Waese. "Our out of pocket expenses were $6,000, the rest of the production costs were donated by companies who actively support cutting edge student work."

One of the first companies to donate to the project was Los Angeles-based Clairemont Camera. Clairemont provided a seldom used 35mm Mitchell camera, valuable to the production because it provided dual pin registration, which eliminates image flutter. Says director Meher Gourjian, "Hardly anyone shoots with a Mitchell anymore, so in a way they were happy to have us use it. It was definitely a godsend but it had its own drawbacks because the camera itself weighs a ton. And when you turn on the motor, it goes grr, grr, grr, grr, grr, like a tank. It's an absolutely amazing piece of equipment but it's so big, that it burned up half our film before it even got to speed."

Once Clairemont was onboard as a donor to the project, other firms quickly jumped on to help lessen expenses for the ambitious project. The following is a full list of "Plug" sponsors: Cinesite, Pacific Title Digital, E-Film and Digital Filmworks provided scanning; Silicon Graphics and Quantel Domino—hardware and software; Microsoft Softimage—software; Clairemont Camera—camera equipment; Kodak—film stock; Solitaire—film recorder; Avid—editing equipment; Fotokem/Foto-tronics—processing and telecine; A&I Photos—still images processing; and Dolby Laboratories donated free use of their digital surround sound format.

Concept artist Michael Weideman created costume sketches full of apparatuses devised to keep the real world out and the synthetic world in. Here the senses are muffled by gadgetry.

TWO DUCTAPE ZONES
BELOW KNEES
ABOVE ANKLES

Rear view of character costume with extension cord backpack.

I.D. DISCS - STICKING OUT
FROM ANKLES CARRY SYMBOL/NAME
SHOES ARE REALLY IMPORTANT

LIGHTS

Filmmakers Meher Gourjian and Jamie Waese approached the making of *Plug* like a full-fledged feature, allotting time for story development, previsualization, and elaborate storyboards.

Outfitted with eight Silicon Graphic Indigos and two Crimsons (and part way through production with eighteen high-end SGI o2's), the lab boasts more computing power than most independent studios. And, unlike most small houses, the film school has eight Avid editing rooms available to students and alumni on a sign-up basis. The film school also has its own film recorder and, thanks to donations from Lucas and Spielberg, screening rooms for dailies.

"We definitely couldn't have done this project without the computing power of the lab," says Waese. "But, because our project was so ambitious, it still wasn't big enough for our needs."

"Especially," adds Gourjian, "when it came to storage. We were forever loading up a scene, working on it and then downloading it back to tape. There just wasn't enough room to do anything else. Which, you can imagine, took a lot of time. At one point I figured out that 70 percent of my time was spent just shoving data down through our pipeline. Which is kind of funny, because when we started I thought I'd spend 70 percent of my time being creative."

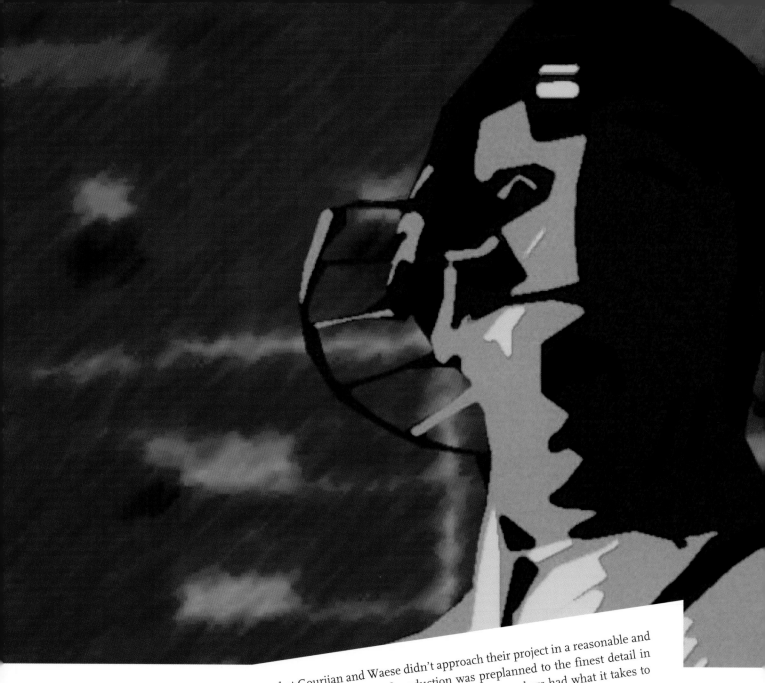

That's not to say that Gourjian and Waese didn't approach their project in a reasonable and even overtly efficient manner. Every step of production was preplanned to the finest detail in order to save both time and money, but also to prove that the filmmakers had what it takes to make it in the big time.

Says Gourjian, "All along I said that this was going to be a minifeature. We're going to go through all the steps that a big production would go through. If Lucas and Spielberg create conceptual art and go through extensive story meetings then we're going to do the same."

So, just like the filmmaking heroes they admired, Gourjian and Waese began work on their "minifeature" by hammering out the story (see sidebar). Over a three-month period they came up with and threw out hundreds of story and gag-related ideas until they found a solid structure. Once the story was locked down, Gourjian began to meticulously board up the events. Meantime, the filmmakers recruited artist Michael Weideman, a transportation design major studying at Art Center of Pasadena, to help with conceptual work.

"I told Michael I wanted a future retro-look," says Gourjian. "Sort of cheesy science fiction. I saw this world as reminiscent of a photograph I had seen once of what Oklahoma and parts of Texas looked like during the 1890s—just a world covered with oil pumps. When I saw that picture, I couldn't believe something like that ever existed; that we would destroy our world for something so meaningless. And that is exactly what I wanted to show in *Plug*—a frenzied world where life is out of control."

THE STORY OF *PLUG*

"*Plug* is our graduate thesis, but the whole process took about eighteen months, three of which were devoted to story development," explains Jamie Waese, *Plug* producer.

"We based our early work on an E.M. Forster short story called 'The Machine Stops' (1909) and a short story my partner, Meher Gourjian, wrote about an old man stuck in a clock tower who, when he is finally freed, chooses his prison over freedom."

This developed into a story about a young man called CAP who, like everyone else in his universe, is "plugged" into a synthetic world.

Plug opens in what appears to be the real world with a beautiful romantic scene between two lovers, CAP and RES, who are enjoying a picnic on a hillside overlooking the ocean.

Suddenly this scene breaks up, as if interrupted by static. This strange interference builds to the point that the SCI-FI machine that CAP is plugged into explodes, throwing him into the world of *Plug*.

As he takes in his surroundings, he notices an intruder; another lost soul who has been expelled from his home and his "plug." Both notice in the distance a working machine in an empty tower. They race to be the first to "plug" back in.

Both characters commandeer flying machines, but as the chase ensues, the intruder crashes into a building. CAP watches the explosion in horror, but does not stop his journey to the tower. When he arrives, he finds the intruder standing on a catwalk leading to the machine. As CAP approaches, the intruder takes off his helmet to reveal that he is the young woman RES from CAP's daydream.

They embrace but CAP decides it is better to find love in the plug than out of it. CAP pushes RES off the catwalk and she falls to her death.

When CAP is transported back to the scene on the beach, the sun is shining, the blue waters roll lazily toward the horizon. This may be paradise, but he is doomed to experience it alone.

Actress Hazel Rhodes as RES, the female lead who comes to a sinister demise.

Jamie Waese morphs from live-action hero to a cartoon in *Plug*.

Following these basic instructions, Weideman created the gadgetry, costumes, and vehicles for *Plug*. Since all the inhabitants of this world are "plugged" into an alternate reality, he made sure that costumes included apparatuses to cover all sensory orifices—thus the odd nose and ear plugs and especially the special goggles, all of which keep the real world out and the synthetic world in. Inhabitants of the Plugworld also wear backpacks that hold massive amounts of extension cord so that they can always stay plugged into the nearest outlet.

For the flying machines used by the lead characters CAP and RES in the chase scene, Weideman and Gourjian envisioned a new take on an old, rather goofy looking favorite—the Bayou Boat. Says Gourjian, "Again, we wanted something that would be sort of tongue-in-cheek. So we thought back to a show we all saw as kids, *Gentle Ben*, and those weird boats with the big fans in the back to push them through the Everglades. That image just seemed right. Of course the flying machines Weideman created are a little more sophisticated but they're still sort of awkward and silly."

Once the story boards were completed and the design agreed upon, preparation for the various live-action shoots began. Says Gourjian, "We could have animated this film using motion capture, but I simply don't like that technology—at least not yet. In five years, maybe. Right now I don't like the way it deals with the human body and the subtleties it misses. We thought we could get further by actually shooting the live action, scanning it and then animating over it, making it look like a cartoon in post. And we also thought it would be a heck of a lot cheaper."

Working on USC's Harold Lloyd Sound Stage, the filmmakers and their volunteer crew set up a series of blocks and bridges that the actors could walk, run, or jump across as if they were traversing the terrain of the computer-animated Plugworld. These were arranged in front of a blue screen and in turn painted blue so that, once the film was scanned, the actors could be cut or matted out from the blue and composited onto computer-animated foreground and background elements.

All costumes were kept to a small range of colors such as yellow or orange so that the director of photography, Patrick Grandaw, could backlight them with similar hues. This would prevent the blue screen from reflecting or "spilling" on the actors, making it difficult to pull a clean digital matte.

Because the set, the screen, and the camera could not be moved, the crew relocated the lighting set-up for each scene. "Since there are no reference points when you shoot in front of a blue screen, we had to establish the space of Plugworld with our lighting set-ups," says Waese.

Just like production on a major feature, preplanning allowed the team to shoot as many as twelve out-of-sequence shots before moving the lights. And, of course, after an afternoon of lifting, carrying, and futzing—along with a few minutes of acting—the filmmakers provided catering. Says Gourjian, "Our craft service was provided by Mom, but her lasagna tasted better than anything you'd get on a big budget feature."

Shooting on stage went on for three weekends. The exterior shots in Malibu, which bookend the piece, were shot over an additional Saturday and Sunday.

After the live action was in the can, it took the team about a month to squeeze in enough time on the campus Avid machines to complete their editing. Once they had a product that was close to their final cut, it was digitally scanned at various post-production houses around Los Angeles.

Next the team worked on creating the software that would turn their live-action minifeature into a seven-minute computer-animated cartoon with a Japanese "Anime" feel. Says Gourjian, "My minor is in computer science, so I had a vague idea of how I could write an algorithm to posterize the live-action characters. I worked with another friend, Louis Siegel, to develop this idea further. After about a month and a half of trial and error, we came up with a very simple program that basically follows the color lines or color areas in a live-action frame. It's sort of like a little worm that's instructed to move forty pixels and then draw a line from the place it started to the place it stops. Then it moves another forty pixels and does the same thing. This straightens out all the lines of color giving it a stylized look."

Gourjian came up with a computerized system for transforming live-action footage into an Anime style.

The filmmakers' careful work in pre-production paid off. The finished product looks exactly like their storyboards.

"It's sort of like a little worm that's instructed to move forty pixels and then draw a line from the place it started to the place it stops," Gourjian says.

After the film was scanned, Gourjian and his team of four volunteer animators pulled mattes of the live-action characters out from the blue screen backgrounds. Then they applied the algorithm. Fortunately the mattes were easy to pull. Unfortunately, the algorithm worked a little too well. Because it was so accurate, it tended to change a great deal from frame to frame, creating an awkward sort of jiggle that was annoying to the eye.

"Actually it was really severe. It really hurt the film," explains Gourjian. "But I used a bit of advice

After computer-generated backgrounds were composited with live-action footage, Gourjian's system was applied to create a posterized effect.

I'd gotten from a traditional animation director named Brad Bird [*Family Dog*]. He suggested just using an old animation trick; dropping out every second frame and replicating the one before." This solution, known as animating on "two's," cleared up the problem.

To create the city of Plugworld, Gourjian animated in Alias/Wavefront. In order to keep the polygon count of the city low for rendering purposes, the overall blueprint was extremely simplistic. Essentially a topography of twelve boxes of varying sizes, the city is a jigsaw puzzle of simplistic elements shuffled together in different ways for different shots. Depth was added through the sparing use of shadows and fog. Background elements were given color and texture by manipulating color controls within Alias/Wavefront so that they appeared to have a flat almost cartoon look like the foreground live-action elements.

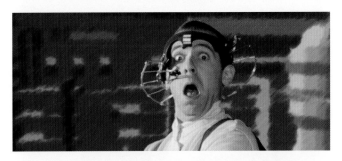

Another saving grace for keeping rendering times low was the fact that the background is in motion for much of the film and is not always clearly seen. Therefore little detail was necessary to make it appear realistic. However, foreground elements such as the Flying Machines were given extra touches such as a metallic sheen on their skins and transparency texture maps on their windshields.

In addition to the many cutting edge systems created for the production of *Plug* was the use of an anamophic screen ratio—a ratio equivalent to the 2.35:1 wide screen standard. Says Waese, "The wide screen 2.35:1 ratio is usually created as an optical effect, but we're doing it as a digital stretch. This is something that major studios are just starting to experiment with, and we're beating them to the punch."

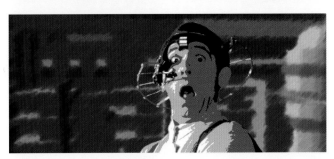

Rendering the animation was the final battle. Even with the fairly hefty set-up at USC, it would take longer to render the film than it did to create, prep, and film the movie. "Actually we got really lucky. Late in January of '97 Silicon Graphics came through with eighteen brand new "02" workstations. Even though we ended up rendering everything here at USC, it still took another four solid months to get the job done," says Gourjian.

Today, this seven-minute wonder is actively touring the festival circuit and doing what it was meant to do—thrilling audiences and impressing the movers and shakers in Hollywood.

Animation for television demands high-quality work produced on incredibly short deadlines. All-night stints are the norm for artists rather than the exception.

Television has always been a proving ground for breakthroughs in computer animation. Sometimes, too, it has been a venue for previewing new effects, but typically it has been the place where new technology has moved from a crawl to a sprint.

When logos began to fly back in the late '70s, they appeared first on TV. Morphing gained popularity on November 4, 1991 when MTV broadcast the computer work of Pacific Data Images in Michael Jackson's video "Black or White"—that astounding piece in which the faces of people from different ethnicities transform one into the next. Although the morph appeared earlier, this short film set the standard for the rush of commercial morphing to come. And in the mid-'90s, television is the medium to make economical use of motion capture.

This section highlights three examples of computer animation for the small screen. Mainframe's *ReBoot*™ was the first fully computer-animated series. As you might expect, the ambitious nature of the project itself is a worthy story. But if you think series deadlines are a crunch, take a look at the incredible work (Colossal) Pictures did to turn around a fully computer-generated commercial with no camera cuts in less than two months. And finally, another wacky first: the making of Medialab's *Donkey Kong* series, 70 percent of which is created through the use of performance animation technology. Never before had this technology been incorporated into prerecorded, for-broadcast production.

Television
It's a Wonderful World

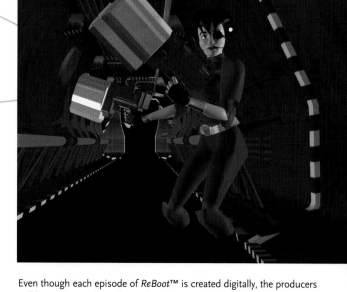

Even though each episode of *ReBoot*™ is created digitally, the producers still have to meet the eight-week-or-less turnaround broadcast schedules.

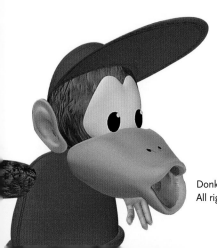

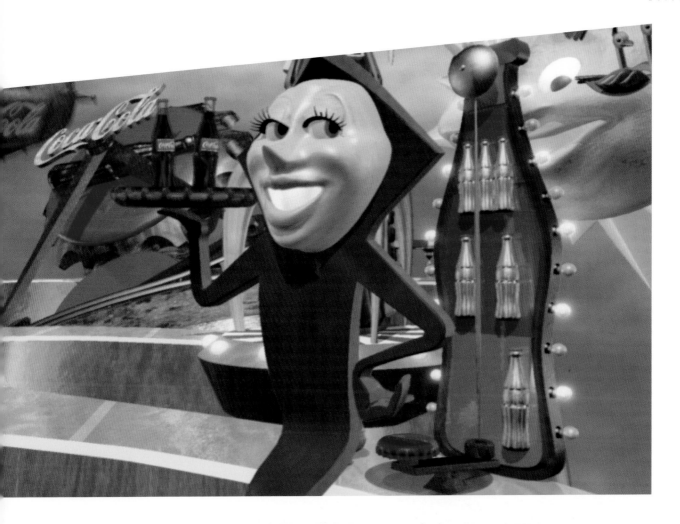

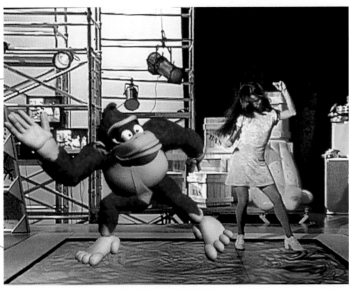

Medialab's Donkey Kong does a real-time turn on the dance floor.

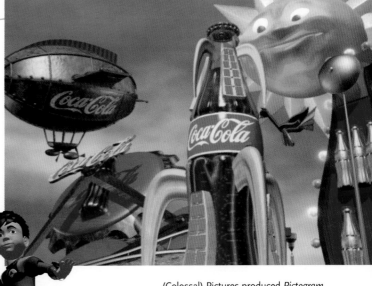

(Colossal) Pictures produced *Pictogram*, an amazing game board tour that follows the path of the "Coca-Cola" logo.

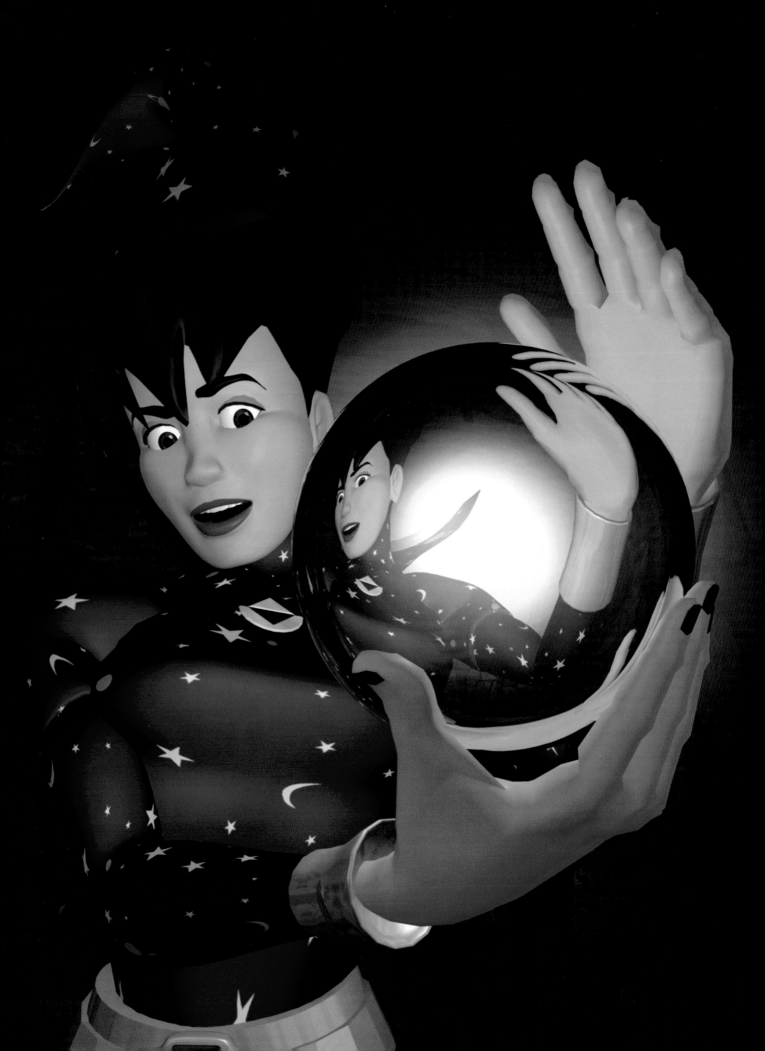

MAINFRAME™
ENTERTAINMENT, INC.

Mainframe Entertainment, Inc., a computer animation studio located in Vancouver, Canada, has produced over 1,100 minutes of fully computer-generated animation, or 1.6 million fully rendered final frames of video in less than three years. At least 75 percent of that Herculean number were produced for *ReBoot*™, the world's first fully computer-generated television show.

Between 1995 and 1997, the team at Mainframe Entertainment, Inc. received four Gemini Awards (the Canadian equivalent to the Hollywood Emmy) for the production of *ReBoot*™. Three of these were for "Best Animated Program" and the fourth for "Outstanding Technical Achievement."

Says vice president of software development Chris Welman, "I was the first software guy involved with *ReBoot*™ and I have to tell you, one of the reasons I came onboard was because I was fascinated with the idea—it was so far out there. Nobody had done anything like this before and as far as we knew, it was impossible. Then again, that's exactly the reason we all took it on—because nobody else was crazy enough to do it!"

And crazy the project proved to be. Not only did the small group (Mainframe opened its doors with fifteen staffers and quickly grew to over 170) have to figure out how they were going to output enough animation to fill up the twenty-two minutes required for television; they had to complete each episode on a television deadline—a meager six- to eight-week turnaround.

I come from the net. Those systems, peoples and cities . . . to this place—Mainframe. My format? Guardian: to mend and defend my newfound friends, their hopes and their dreams, to defend them from . . . their enemies. They say the user lives outside the net and inputs games for pleasure. No one knows for sure but I intend to find out! ReBoot™!
—**Bob: The Guardian (ReBoot™ Title Sequence)**

(Opposite page) Outgoing, fearless, and one heck of an entrepreneur, *ReBoot*™'s heroine, Dot Matrix, is regarded as one of Mainframe's community leaders.

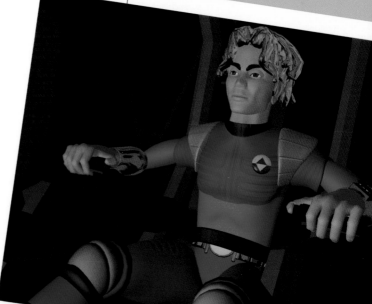

The world's first fully computer-animated series, *ReBoot*™, focuses on the lives of three central characters: friends Bob and Dot, and Dot's little brother Enzo, in the bustling city of Mainframe (left), a metropolis constantly invaded by "Games" played by unseen Users. Upon arrival of an incoming Game, the city shuts down and our heroes "ReBoot" to become character players within the Game.

Says Welman, "To do that, we had to rethink the traditionally accepted standards of animation production flow. That turned out to be such a brain-teaser that it's definitely proprietary. But what I can tell you is that our system didn't come about overnight. We struggled with it for the first three episodes and we've been refining it ever since."

Although the first three episodes of *ReBoot*™ were trying, the crew did enjoy a relatively long ramp-up before jumping feet first into production. Approximately fifteen months were dedicated to solving software challenges and creating a library of character models, character movement cycles and backgrounds that could be used and then recycled from episode to episode.

"One of my early challenges," says Welman, "was not only how we were going to make our characters talk but how we could make them talk in an efficient manner, giving animators quick, easy controls over the process. At the time there wasn't any software on the market that could do that, so I spent the first six months of my job writing a solution."

During that time Welman issued new versions of his lip-synching software on a weekly, sometimes daily, basis. As soon as he got feedback on the program's effectiveness—

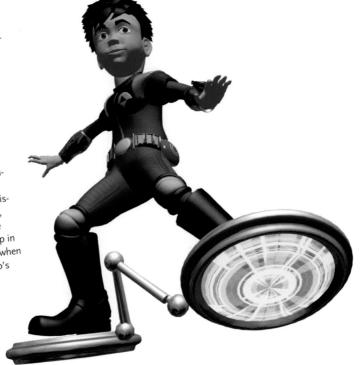

Enthusiastic and adventurous, Enzo is always getting himself into mischief. He idolizes Bob, and, in Season III, the young Sprite grows up in more ways than one when he is asked to fill Bob's shoes.

or ineffectiveness—from the animation team, he headed back to his digital drawing board and began the laborious task of manipulating algorithms to fit the artist's needs. "It may not sound like it, but that was actually a fun project, mainly because I could see the results of my efforts immediately in the animator's work. And a lot of times the feedback I got from the artists was really inspiring. It pushed me to come up with something beyond what I thought I was capable of."

Welman wasn't the only programmer busy writing code for the production of *ReBoot*™. Because Mainframe made the decision to be a beta test site for the Microsoft Softimage animation software, Softimage 3D, the animation studio was in daily contact with that software developer, tracking any bugs in the program and consistently asking for new tools or versions that served their particular needs. Says *ReBoot*™ creator Ian Pearson, "I'll have to admit, ultimately it was a very stressful process for both parties because what we were asking the Softimage product to do just wasn't possible at the time. Then again, the whole idea of doing a series had only just become a possibility due to the creation of the R4000 chip inside Silicon Graphics Computers. When that chip became available, rendering speeds jumped up 50 percent—just enough to meet television deadlines."

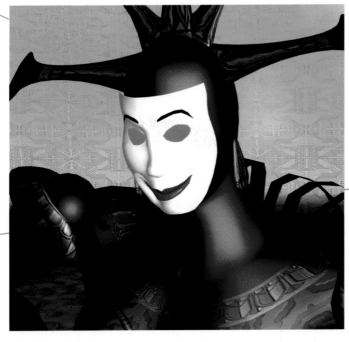

Mainframe's Queen of
Chaos, Hexadecimal,
the virus who thrives on
malfunction and lives in
a warped section of the city,
called "Lost Angles".

The creation of models was not a stand-alone process. Much like designing for the stage, each element—whether character, prop, or background—had to fit into the overall look of *ReBoot*™; all of which required a great deal of preplanning.

Says designer Brendan McCarthy, "You have to remember that we were creating an entire world. And not only did that world have to have its own continuity, it was regularly invaded by a Game from another world.

All in all it was a hell of a lot of work. In fact, by the time we'd finished our third season I think we had designed more computer graphic elements than anyone on the planet."

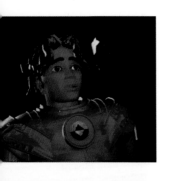
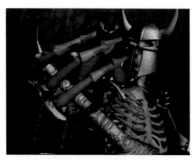
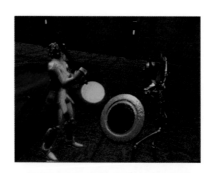

"I was given the two-and-a-half-minute swordfight between Bob and a skeleton on the episode 'The Quick and the Fed.' I've always been a big Ray Harryhausen fan, so it was fun to rent all the old Sinbad movies and brush up on the stop motion skeleton fights."—Andrew "Spanky" Grant, animator.

Before any animation could be rendered, models had to be created. Co-creators Ian Pearson and Gavin Blair recruited Brendan McCarthy, a comic book artist best known for his exceptional work on the *Judge Dredd* comic book series to design the look for *ReBoot™*, both the world and its characters. Working hand-in-hand with McCarthy, digital model-makers began to sculpt both the characters and the unusual world of *ReBoot™*. The lead characters, the Guardian Bob, the entrepreneur Dot, and her little brother Enzo, along with the show's rogue gallery (characters like Hexadecimal and Megabyte) were designed first.

But taking McCarthy's two-dimensional drawings and recreating them in three-dimensional space was not a simplistic process. For instance, the villainess Hexadecimal may look a lot like her original drawing; she has the spiky shapes, the ribboned cape, and the overall ice-queen-meets-Kabuki-star look of her first hand-drawn rendering, but elements of her physique had to be subtly manipulated to fit the digital medium.

Says McCarthy, "Hex didn't look right when she was modeled in the computer; the model lost the feel of the drawing. So we had to exaggerate the shapes of her anatomy by lengthening her legs and decreasing the size of her joints. This gave her the slightly kinky look I was going for."

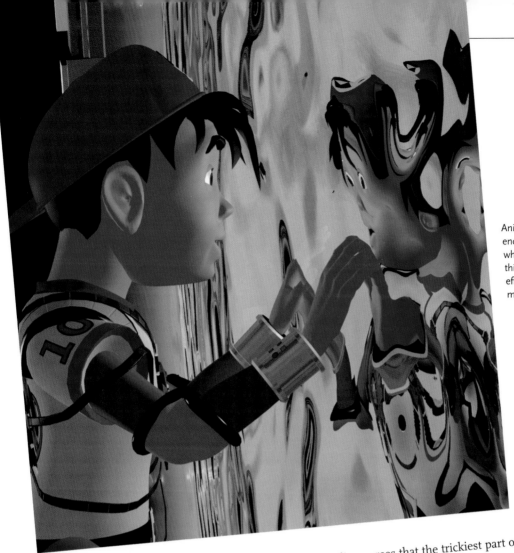

Animators rely on references from nature, even when creating out-of-this-world special effects like this shimmering barrier of liquid.

Modeler Frank Belina agrees that the trickiest part of taking a 2-D design to 3-D is maintaining the energy of the original. "I find that reference material, from books or videos, helps. Just looking at how something similar works and looks in real life—how light falls on it, how it's put together—is very helpful. But a lot of times what works is just applying some standard tricks that you build up over time. It's the same thing in other fields, especially special effects. You don't build all four sides to a miniature if the audience is only going to see one side. Often a lot of the creative work in model building comes down to preplanning—figuring out what trick is going to work best."

When Belina creates a character model for *ReBoot*™, he begins with a sketch or a sculpture. Then he spends time examining that piece of art, figuring out how all the pieces will fit together in 3-D space. Next he begins to sculpt on the computer. "I build models section by section. If a model is really tough,

Frisket, the ever-faithful alley stray, whose bark is much worse than his bite.

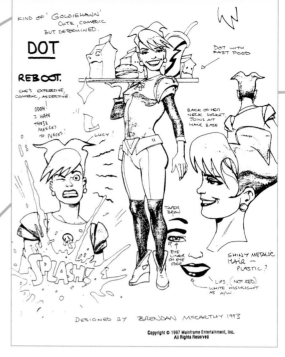

Early concept of the original Dot.

For Season Three, which premiered in the Fall of 1997, the entire cast of *ReBoot*™ received a make-over. Says Pearson, "We've taken five steps up in quality at every level. Now that we own the series it's become a hot bed for testing our skills. We're really able to take risks with it. We've added shadows and more intricate lighting, but most of all we've enhanced the characters, giving the models subtle controls so that animators can really show in-depth emotions."

The re-vamped Dot in *ReBoot*™ Season III.

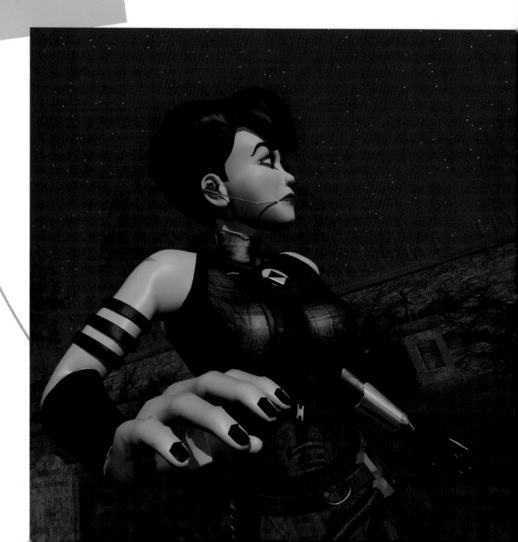

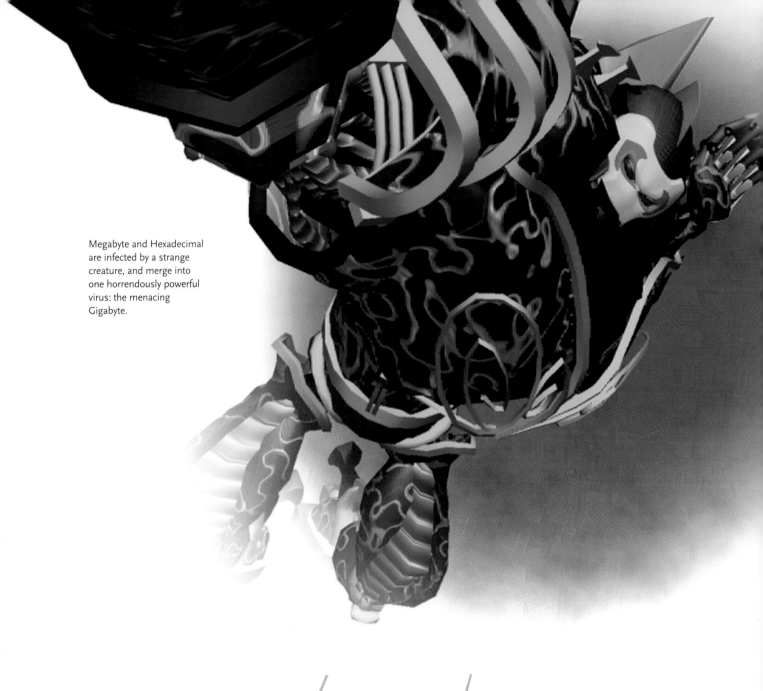

Megabyte and Hexadecimal are infected by a strange creature, and merge into one horrendously powerful virus: the menacing Gigabyte.

I look for something that will hook me into it; get my creative juices flowing. Usually that's the head. Then I sort of rough out all of the other parts trying to find a balance between them."

To do this Belina typically begins by creating a sphere made up of "tag points." By grabbing and manipulating these points he slowly sculpts each section, pushing the digital points around much like he would to form clay. Once all of the sections (called *patches* in Softimage) are created, they are attached to a "skeleton" that reflects the basic shape of the character's anatomy. This skeleton can be moved much like a body in the real world. If a hand is pulled, the entire arm will follow the hand, a system known as *inverse kinematics*. Then Belina refines the model and tests it to see whether or not the skeleton, along with all its patches, will move without flaws (without a joint poking up through another, for example).

The last process in character model creation at Mainframe is building textures for the skin, clothing, or hair of the character. Typically Belina paints the look of these elements using a Softimage tool, but sometimes he goes to other paint programs such as Adobe Photoshop and then imports these creations into Softimage. Once textures are applied, the model is stored in the ReBoot library for use by animators.

For the production of the first three episodes, animation was doled out to artists as it is in traditional feature film production—by character. One animator was given the scenes with Dot; another the scenes with Bob. But since a majority of the lead characters appear together in most scenes, this system became unwieldy. Instead of specializing in the animation of a particular character, *ReBoot™* animators were forced to quickly become expert generalists, able to animate all the personalities on the show.

During the first few episodes the production team worked with hand-drawn storyboards, but this too became inefficient. Says animator Andrew "Spanky" Grant, "Going from 2-D drawings to a 3-D universe hindered more than helped. We still create storyboards but we do it digitally within Softimage by pulling elements from our library and laying them out."

After the storyboards for an episode are refined, animation directors hand out scenes to animation supervisors who prepare them for the animators. All the elements of a scene—backgrounds, character models, and props—are brought into Softimage and quickly placed in approximate positions for the beginning of the scene.

Dot doesn't like Games, but will fight hard if trapped in one. Here, she is seen brandishing big weapons in "The Tiff", episode 5 of *ReBoot™* Season I.

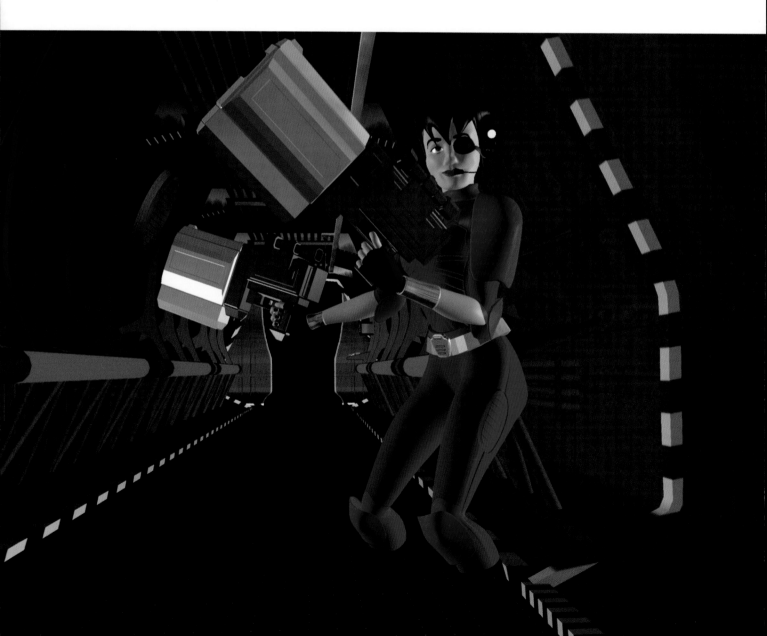

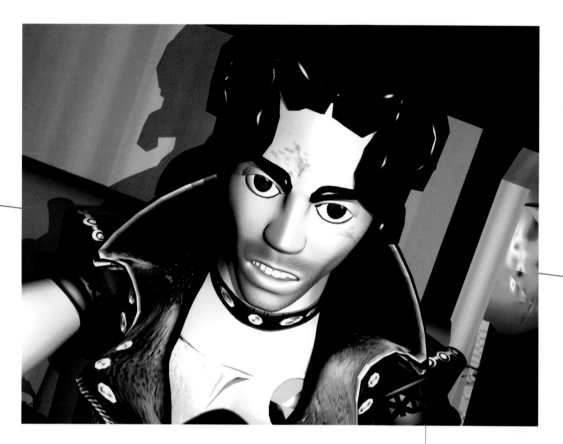

Inside the road race Game in "Bad Bob" from Season II, Bob reboots as a leather-clad driver who must race to save Mainframe from destruction.

Then, following the digital storyboard, the supervisors place the virtual camera and lights.

Once a scene is prepared, the animation director doles it out to an artist based on the scene's complexity. Animation director Michaela Zabranska explains, "The most difficult part about directing is the people skills. You're working with a whole crew of artists, all at different levels who all take different approaches to their work. You have to be able to explain what you want to a beginner and at the same time keep the experienced animators excited about their work."

Before Mainframe animators sit down at their computers, they carefully plan out the action of the scene. Says Zabranska, "Everyone has a full body mirror in their suite. So each animator begins by acting out the sequence for timing in front of their mirror. Then, they come back to their director and discuss their timing and character motivations, all before they start to animate in Softimage."

Once a basic plan is hammered out, the artist begins animating by roughing in the major movements of the characters in the scene. Animation scenes develop much like watercolor paintings, step-by-step and layer-by-layer. After the most extreme movements are created, more subtle movements are added, with the computer "in-betweening" the finest.

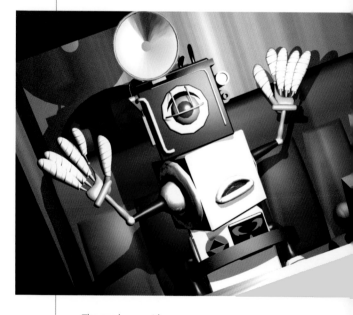

The non-humanoid Binomes dwell in Mainframe with their humanlike neighbors.

71

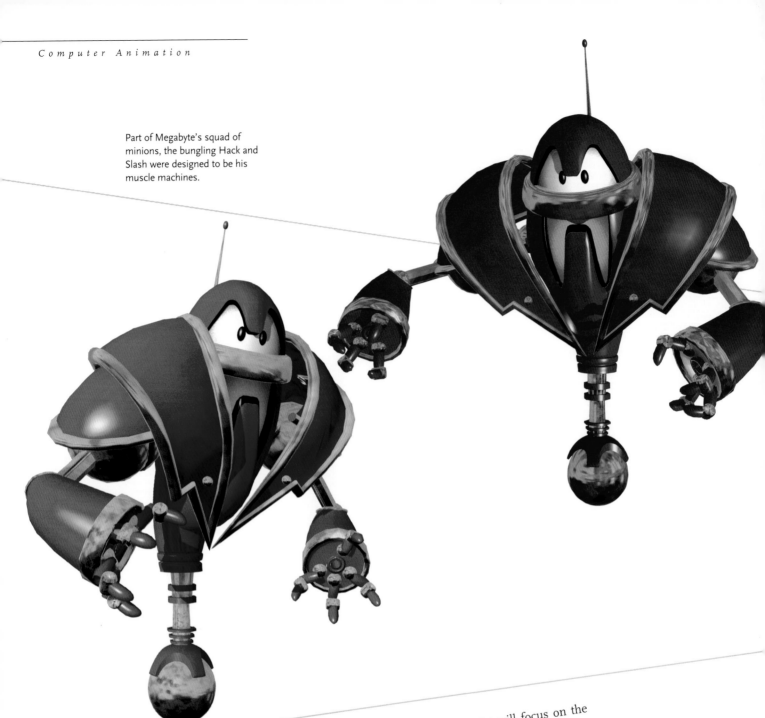

Part of Megabyte's squad of minions, the bungling Hack and Slash were designed to be his muscle machines.

If a scene requires two characters to interact, the artist will focus on the main character first. Explains Grant, "It's always best to animate one character at a time, especially if there's a lot of gesturing or action. I always animate the principal first in order to get my timing down and then base the other character's timing on the principal."

Animators test their work in a simplistic form on their computers. In this low-resolution or "low-polygon" count model, characters appear to be made of plastic tubing. It is an odd look, but gives the artists enough feedback to continue refining their scene.

Once an animator feels comfortable with the movement and timing of a sequence, he or she sends the "test" to an editor who renders and composits it, giving the artist a better idea of how the finished product will look. After the team—the director, supervisor, and animator—has a chance to go over the work and provide notes, the animator goes back to the suite to make the necessary corrections. When a scene is signed off, it goes back to editorial to be cut in with other incoming scenes.

Once editorial has completed its task, the twenty-two minute episode is sent to a post-house for a final master edit in which broadcast standards are applied. *ReBoot*™ airs in over sixty countries for audiences of all ages to download.

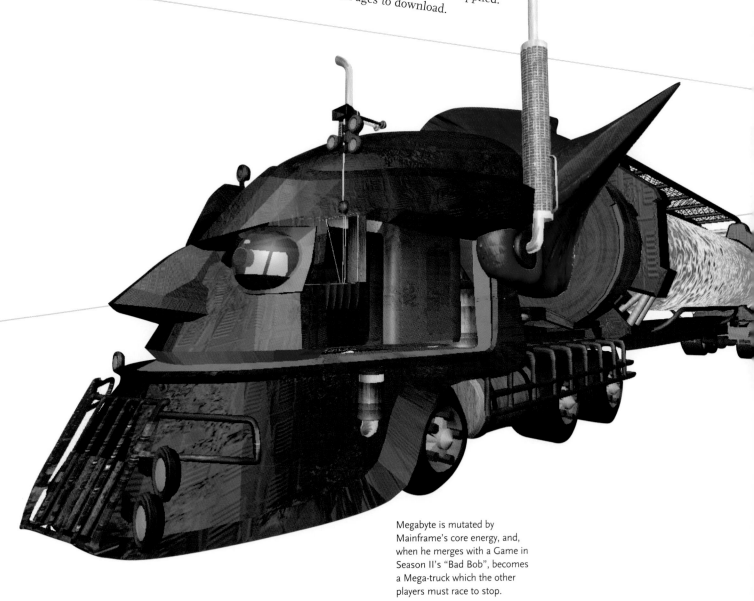

Megabyte is mutated by Mainframe's core energy, and, when he merges with a Game in Season II's "Bad Bob", becomes a Mega-truck which the other players must race to stop.

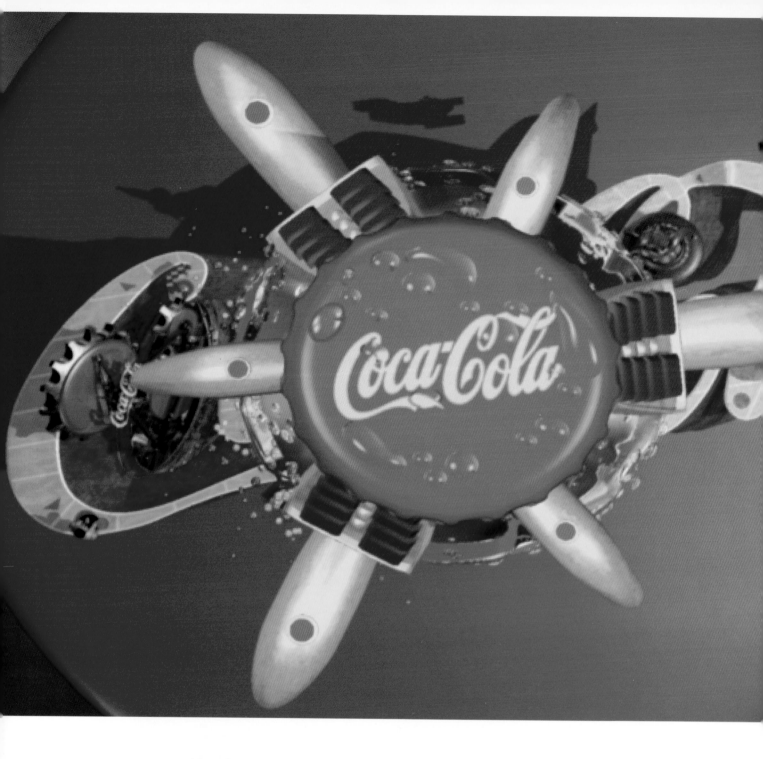

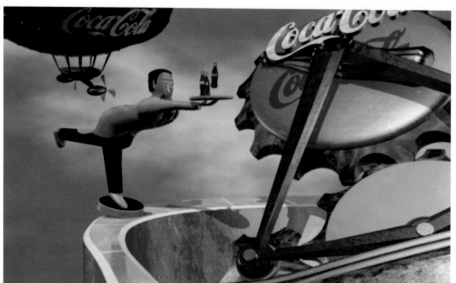

The legendary "Coca-Cola" logo doubles as a rocket ship propeller above, and graces dozens of zany gadgets in the game board world of *Pictogram*.

All images this chapter appear courtesy of The Coca-Cola Company. ©1997 The Coca-Cola Company. All rights reserved.

Pictogram is filled with vehicles and gadgets modeled after the look of tin toys.

(Colossal) Pictures

Coca-Cola/Pictogram

The creation of a "Coca-Cola" commercial has become its own modern art form. To be awarded a "Coke" spot is not only an honor but a chance for an animation house to really let loose and be creative—something that doesn't happen very often in the buttoned-down world of commercial production.

"Aside from a few stipulations about getting the caramel color of the liquid right and the dew drops from condensation on the bottle—all those elements that are important in terms of appetite appeal—you pretty much have total freedom," says Drew Takahashi, president of (Colossal) Pictures.

(Colossal), a San Francisco-based animation studio famous for its "blendo" style—the wild combinations of various media (live action with stop motion animation, cut-out animation with computer,

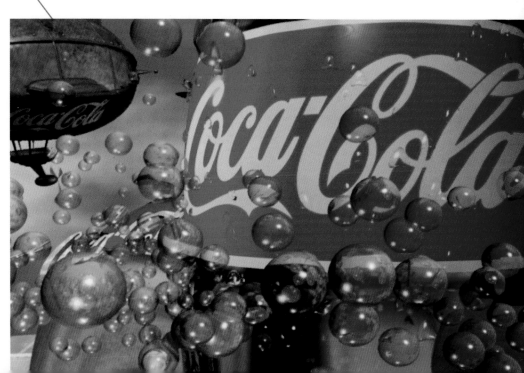

Unlike many commercial clients, Coca-Cola likes to give animation houses a great deal of creative freedom.

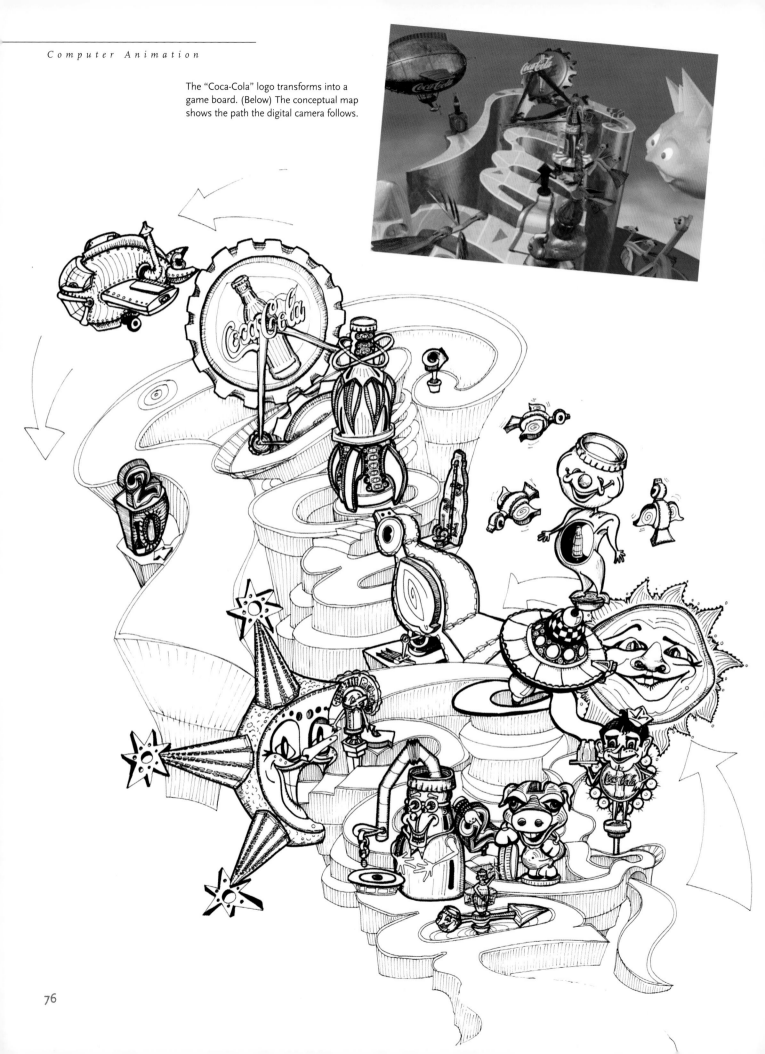

The "Coca-Cola" logo transforms into a game board. (Below) The conceptual map shows the path the digital camera follows.

The *Pictogram*
storyboards.

etc.) was awarded one of the most interesting (and ultimately non-blendo) "Coke" spots ever created. Called *Pictogram*, this thirty-second entirely computer-generated short takes the viewer on a kooky ride through a retro '40s style game board.

"The original idea," remembers Takahashi, "was to take the lyrics of the "Coke" song and represent them graphically. So the look was very illustrative, more art oriented. But as we started working with the ad agency, Edge Creative out of Los Angeles, we came up with more refined ideas."

The idea that stuck to the wall was to make the game board path the actual "Coca-Cola" logo. Explains (Colossal) creative director Mark Frankel, "We all remembered the great game boards we grew up with as kids and the heritage those game boards honor—of a seemingly flat two-dimensional world that expands into a marvelous three-dimensional world when you take it out of the box. That magic is what we decided to capture."

Detailed drawings by Tom Rubalcava were used as reference by digital modelers.

Once this concept was agreed upon, it was quickly embellished. All involved agreed that the game board should take the viewer back in time to a simpler era of great character logos and tin-type toys. But the twist that would grab modern audiences would be a crisp, clean, engaging world created through computer animation.

"We worked on the backstory for a few days—which is a lot for a commercial production with a tight deadline," says director Jill Sprado. "We drew a map of the path the characters would follow and actually figured out what it would take to win the game. The first game piece to make it to the end with the most "Coke" bottles in hand wins!"

During the preproduction stages, artists at (Colossal) designed the three main character pieces that follow, just ahead of the camera, the path of the logo. (The viewer's point of view is actually the fourth game piece.) These game pieces were given the in-house names of "Ice Queen," "Garcon," and "Pop Top." After drawings of these three characters were approved, (Colossal) artists moved on to create the look of the game board's twenty-six gadgets.

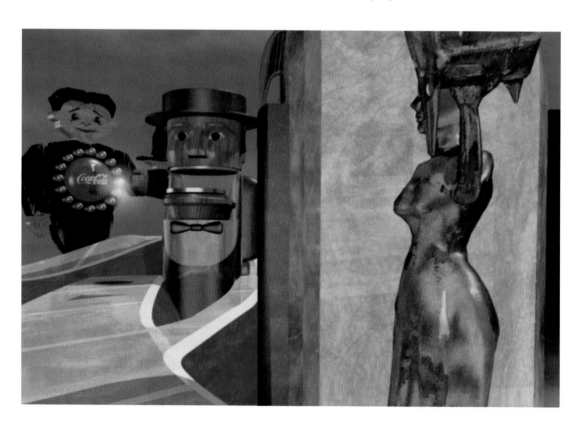

The goal is to make it to the end with the most "Coke" bottles.

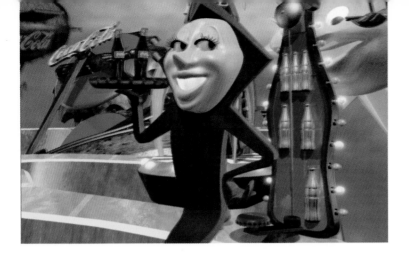

A 2-D drawing
transforms . . .

③

. . . into a 3-D model.

Once all the 2-D models were designed, artist Tom Rubalcava began to story board the animation. "That was pretty tricky," remembers Rubalcava, "because the spot is one continuous camera move—no cuts. So everything had to be staged and choreographed perfectly, which again was difficult because I was trying to create a 3-D world with a 2-D drawing. To keep everything straight I had to keep referring to the map we'd made. Sometimes what helped was actually tipping the map on its side at about a 45 degree angle so I could start to get a little perspective going."

Models and story boards complete, (Colossal) sent the 3-D modeling and animation to two outside houses, Click 3 West and Little Fluffy Clouds Digital Animation and Design Studio, both of which were located in the Bay area and staffed, or partially staffed, by former (Colossal) employees. [(Colossal) downsized its operation in 1996, the upshot of which was a crop of new animation houses that popped up around the city. Little Fluffy Clouds took to the skies at this time and Click 3 West acquired a few new employees.]

Surface textures
are applied . . .

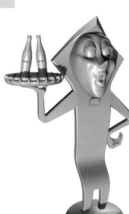

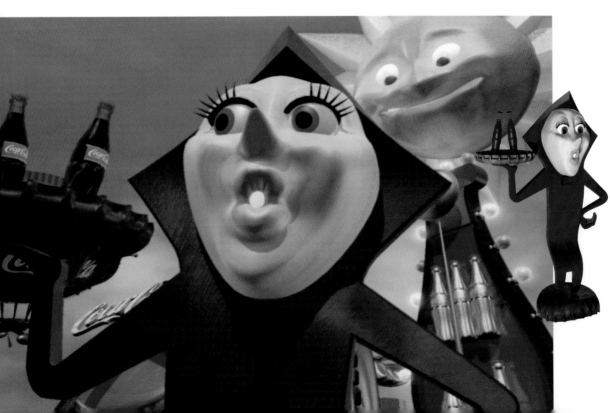

. . . and details
are added.

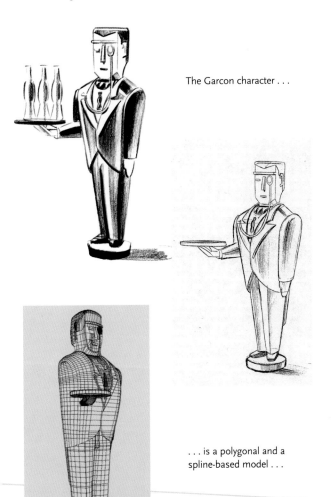

The Garcon character . . .

. . . is a polygonal and a
spline-based model . . .

. . . animated using
lattice deformation.

Says producer Brian Sullivan, "This was definitely a unique situation, to be working with vendors who used to be our employees. So it was a little like subcontracting with family. It was like the good old days but better, because all of us had something to prove: that we could make a spot the likes of which no one had ever seen."

Little Fluffy Clouds, a 3-D boutique house run by Betsy De Fries and Jerry van de Beek, was responsible for modeling and character animation, with their main focus being the three game pieces. For the Ice Princess the team created a polygonal model in Softimage.

Says van de Beek, "The animation technique we used on the Princess is called *skeleton deformation*. That's basically a grouping of bones that are placed inside the shape of the model. The model then becomes, literally, the flesh on the bones. By moving these bones—pulling on a hand, for instance, will move the entire arm—you can move independent parts of the model without being overly concerned with the displacement of geometry."

The Pop Top or Bottle Opener character was a combination of a polygonal and spline based model and was animated with a skeleton and a lattice deformation. Explains van de Beek, "Lattice deformation allows you to capture or surround a model with a three-dimensional grid. This lets you pull at specific points on the grid which makes the model change shape or deform along with it."

To animate this metallic character's hands, several different models were created. The combination of these "model replacements" allowed van de Beek to create realistic movement for a very unrealistic character. "I have to admit," he adds, "it was a bit of a mind bender to figure out how I was going to get a flat metallic arm to move like the rest of the character's 3-D body. I could twist the arm and rotate it, but I couldn't keep the flat look of the metal I wanted. So the simple solution was a cheat. I simply created additional models for those body parts and placed them in as needed; just like how you work with a stop-motion character, replacing a head with a sad expression with another that has a happy expression but keeping the same body."

In fact both De Fries and van de Beek point out that whenever they get into a sticky situation in the digital realm, they always go back to the basics of traditional animation. Says De Fries, "The big thing for us is to always give a nod to traditional animation, to always keep those techniques in mind because they are the very basis of what we do."

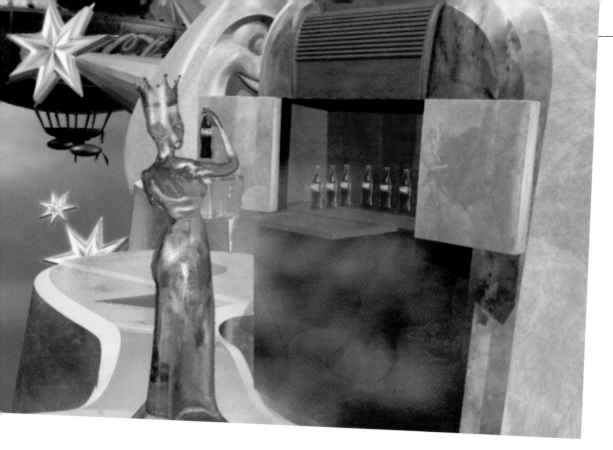

The three game pieces
were created by artists
Betsy De Fries and Jerry
van de Beek of Little Fluffy
Clouds.

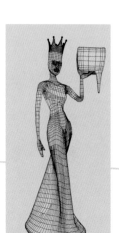

81

After the Garcon character was complete (another polygonal and spline based model, animated using lattice deformation), the team sent their work along the production path to Click 3 West. Click 3 West is the West Coast offspring of the New York-based "open architecture" digital effects house, Click 3. Like its sister operation in the Big Apple, this company by the Bay boasts a stable of SGIs, Macs, PCs, and Flames.

"We were responsible for building the digital path which Jill, the director, wanted to see," says animator Jamee Houk of Click 3. "We built that in rough form as just a spline—or flexible line—within the computer and then hooked the camera to that. Then we'd all watch the camera track the line and if it wasn't going where Jill wanted, we'd just push and pull the grab points of the spline around."

Meanwhile Houk's team modeled the many gadgets in the shot. "Those took awhile," says Houk, "because they were extremely detailed. I think each of the gadgets took about two days to complete." Most of the textures for the gadget models were created in the Macintosh graphics department at (Colossal). These were shipped via the Internet to Click 3 West and then applied.

From a Little Fluffy Clouds
work-in-progress entitled
Go Fish.

Image appears courtesy
Little Fluffy Clouds.
©Little Fluffy Clouds

Once all the models were completed, they were placed along the logo path. The twists and turns that the camera takes to look at these gadgets were based on the placement of the models. The biggest headache quickly became working with huge amounts of data. Each time a new model was placed along the camera's path, the polygon count jumped up astronomically.

Says Houk, "We ended up working with about 1.2 million polygons. It was so much data that it was difficult to move through the scenes. We would render everything in wireframe, which took all night, and then look at it in that form in the morning. But everything moved so slowly it was difficult to get a sense of how it would all fit together once the models and animation were fully rendered and composited."

Because the file sizes were so large, the Click 3 West team was never able to see the entire spot before it went to their in-house post department for completion. Even with the addition of rented hardware—two Onyxs and a Challenge—the animators still had to view their work in small cuts.

The sun marvels at the pace of the game.

At the end of *Pictogram*, a "Coke" bottle shoots off like a rocket, leaving behind a cloud of bubbles. The transparency effect for these bouncing bits of carbonation was created by Bob Roesler of Click 3 West.

Says Roesler, "The bubbles were animated and rendered in Softimage. To get the refractive effect, we used a technique called displacement mapping. This allows you to add relief to an otherwise smooth image by using the greyscale of a second image. In this case an alpha, or matte, of the bubble shapes—white where there were bubbles, black where they were not—was used in the background where the bubbles were. The transparent bubbles with their highlights were then composited on top of that product for the final effect."

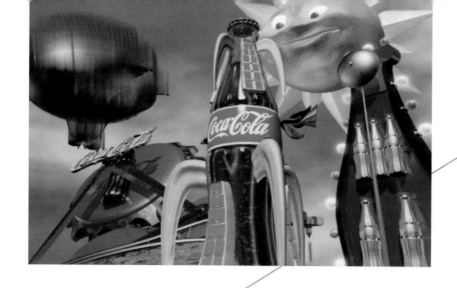

"I will say, though, that working like this really hones your skills. You have to make quick decisions and they have to be absolutely accurate because you just don't get a second chance to render something out," says Houk. "Our motion tests would take up to a day and a half to render, which is unheard of. None of us are used to those slow turnaround times anymore. So it was a little nerve-racking."

The entire spot was composited on Click 3 West's in-house Flame by artist Bob Roesler. "Originally we were going to try and composite this spot using 3-D software, but the world was so complex that we had no choice but to go with our Flame. Once we got everything on the Flame, my most difficult problem was sorting out the many elements."

Each frame was loaded with more than ten models and, with extra effects like chase lights and bubbles, boasted dozens of layers. So it was often difficult for Roesler to discern on which level an element should appear. "A lot of my time was spent cataloguing the elements and figuring out what elements should appear to be in front or in back of others. Usually you can figure this out based on the scales of the objects, but in this world there was no scale."

Once the spot was composited, the final render took many hours, but the result of all that number crunching is a fantastic treat for the viewer. At every turn a new and colorful scene is revealed. The audience member actually feels that he or she is in a game that can happily be played—over and over again!

The "Coca-Cola" bottle ready for blast-off at game's end.

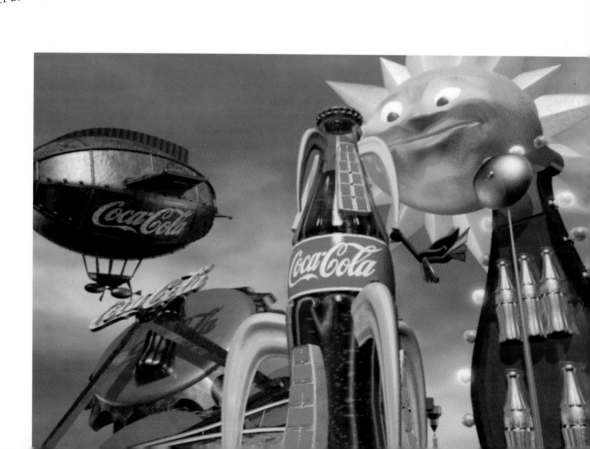

Medialab

Donkey Kong Country

When Medialab bought the rights from Nintendo to make the ever-popular, great gaming ape Donkey Kong into a series, they bit off a very big piece of the proverbial banana. Not only were they dealing with a popular icon, they had to take that icon out of his home in the game world and place him in a new realm, that of a 3-D performance animated series. Explains producer Maïa Tubiana, "Throughout this process we've been in close discussions with Nintendo, trying our best to bring the essence—the real feel of the game— to the series."

Working with their co-production partners, Canadian-based animation studio Nelvana, Medialab creatives first battled to come up with a story line that would fit the game (see sidebar); one that would follow the feeling of moving through levels yet actually provide a beginning, middle, and end to each episode. Once the story line of an ongoing battle between the Apes

Characters ©Nintendo , 1996
Animated TV series: Medialab, Nelvana.

©Nintendo , 1996
V series: Medialab, Nelvana.

Donkey Kong (opposite page) and his pal Diddy (above) rule the game world. With some help from their pals at Medialab, they upped their popular profiles from two-dimensional to three-dimensional.

There's an underground theory in the Hollywood animation community that if you put a monkey in your series, movie, or short (any monkey, even if he's just on for a cameo), your production will be a success. It's doubtful that this wacky hypothesis crossed the Atlantic and made its way to the animation community in Paris, France. But then again, who knows? This could be the very reason that Medialab, Paris chose to purchase the rights to "Donkey Kong" from Nintendo.

Of course the other, more probable, reason is that the marketing gurus at this full-service production studio knew a golden apple (make that banana) when they saw it. What could be more hip than turning the most popular 3-D game into a computer-animated series? Not only did "Donkey Kong" have a ready-made audience, but the lovable chimp lived in a cool place we'd all like to escape to—the jungle.

However, turning a multilevel nonlinear game into a television show took a little doing. Working with writers at co-production house Nelvana, the Donkey Kong Country team focused the story on the island of Kongo Bongo and a continuing threat to the Apes—the Reptiles. In the series, King K Rool of the Crocodiles is forever trying to steal the Apes' magic Crystal Coconut.

This special nut revealed Donkey Kong to be the Apes' future king and when he comes of age will give him the powers he needs to keep his realm together. Until then DK and his pal Diddy have to keep those rotten reptiles at bay.

It's an actress, not an actor, who supplies the outrageous gestures for TV's Donkey Kong.

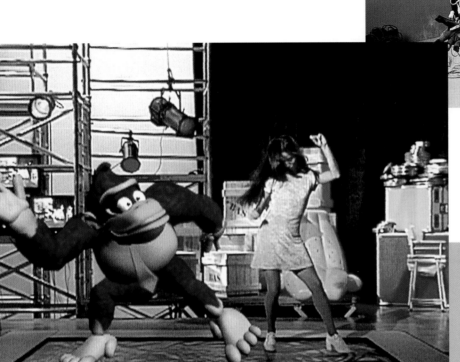

When he's not busy making his series, Donkey Kong appears as a co-host on a French news magazine show for kids. Unlike most of his computer-generated peers, the big DK performs live.

Medialab specializes in performance animation rather than motion capture. Both media capture data based on the motion of a performer. The difference between the two is that performance animation is captured in real-time allowing the performer and director to collaborate easily.

Director of performance animation on the television series *Donkey Kong Country*, Laurent Juppe says of his work, "I explain things to the actors the same way any live-action director would. I tell them where the other characters in the scene will be placed, what it is they're reacting to. And I tell them what emotions I want. We'll try a take and look at the results. I'll make notes and we'll try it again. This sort of work is very much like directing for the theater so it's very fulfilling."

Juppe adds that it has been interesting to watch the traits of the actors subtly appear in the animated characters. "People are definitely cast for these roles. Their own personalities become linked to the animated characters. So it's like working with a little ensemble. Now I know instinctively when we get a new character in an episode just which of my troupe would be right to play that part."

and Reptiles of Kongo Bongo Island was established, the writers and development folk beefed up the personalities of the characters.

For example, the someday-to-be-king, Donkey Kong evolved into a lovable but totally tactless hero, always putting his stomach in front of his head. Little Diddy became the brains to Donkey Kong's brawn, and Cranky, the Guardian of the Crystal Coconut, became DK's spiritual guide, able to transport in holographic form to warn DK and Diddy of danger.

Once the stories and characters' personalities were refined, artists at Medialab worked to create the look of the characters for the series. Artist Phil Mendez was able to capture the dynamics of these feisty frolicsome beasts by focusing on the oddities of their anatomy—oversized chests and heads, huge arms and hands and tiny torsos and legs. Realizing that his 2-D drawings would be turned into three-dimensional models, he also concentrated on shaping these basic pieces of anatomy into simple geometric forms.

Based on Mendez's model sheets, the Medialab crew began to piece together a plan for recreating the cast in the digital realm. Says Tubiana, "One of the most striking differences between *Donkey Kong Country* and say, *Reboot*™ is that at least 70 percent of *DKC* is created through performance animation. To create models that can be matched to real-time or performance animation takes a lot of experimentation, discipline, and the ability to live with a few compromises."

Just like traditional 2-D animation, computer animation requires character model sheets that show relative sizes of its cast along with front, back, side, and three-quarter views.

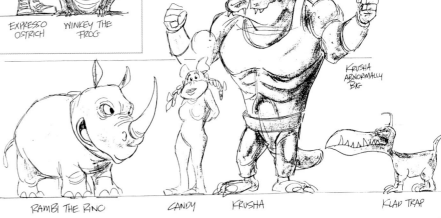

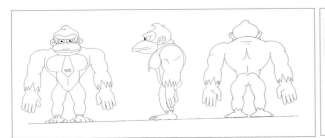

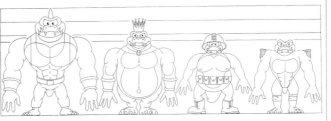

Kongo Bongo is as whimsical and romantic as *Swiss Family Robinson.* Here is a preliminary drawing of one of the island's mythical bays.

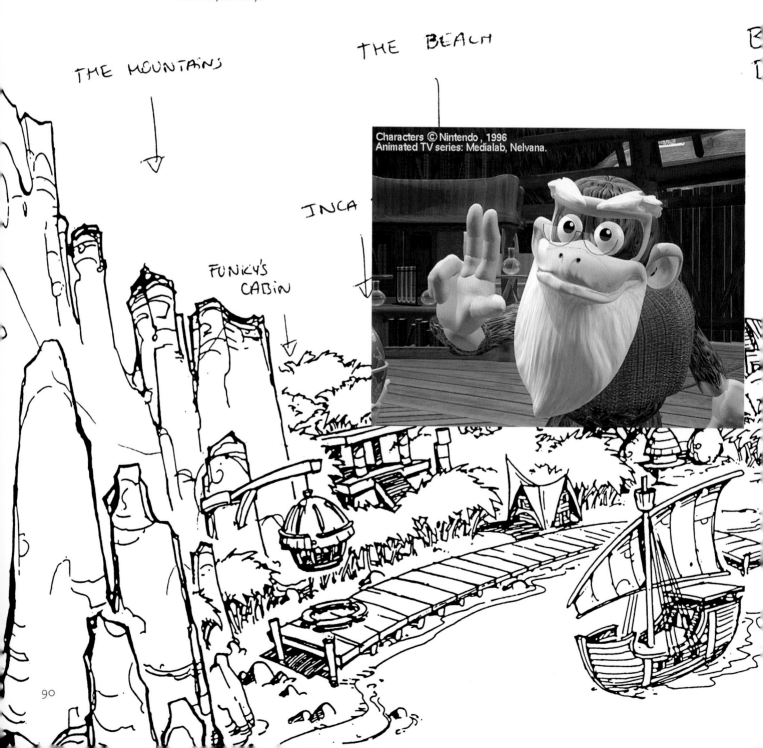

THE MOUNTAINS

THE BEACH

B
[

INCA

FUNKY'S
CABIN

Characters © Nintendo , 1996
Animated TV series: Medialab, Nelvana.

Yet, for the most part, the 3-D cast of *Donkey Kong* looks remarkably like their 3-D game counterparts. The compromises Tubiana speaks of were minor. King K Rool's long cape interfered with the performance animation and so had to be shortened. Dixi's long ponytail also got a slight crop. Facial expressions, on the other hand, were enhanced or exaggerated to give puppeteers running the facial controls on the capture stage more latitude to perform.

After the two-dimensional model sheets were adjusted they were given to sculptors to turn into three-dimensional models. Character bodies were grouped into similar families and created in the computer. Digital skeletons for animals with similar types were built in Alias/Wavefront modeling software. Then individual bodies were generated using this family as the base.

Because of their complexity, character heads were first modeled in clay, which were then digitized by tracing the intersecting points of a grid applied to

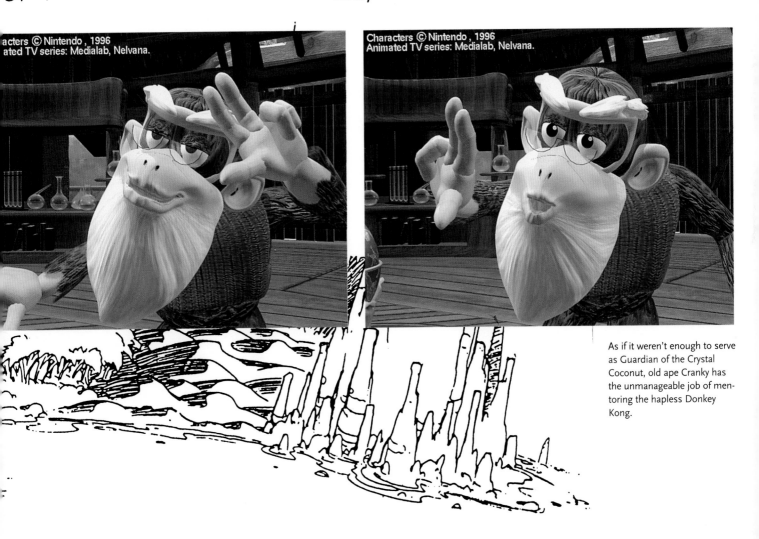

acters © Nintendo , 1996
ated TV series: Medialab, Nelvana.

Characters © Nintendo , 1996
Animated TV series: Medialab, Nelvana.

As if it weren't enough to serve as Guardian of the Crystal Coconut, old ape Cranky has the unmanageable job of mentoring the hapless Donkey Kong.

their surfaces. On the computer monitor this grid appears as a model in 3-D space. It is refined by an "infographist" who adds "controls" that allow animators or puppeteers to move various muscle groups.

"To create the head sculpture takes about a week, because it involves a lot of back and forth between the digital artists and the sculptor. The goal is to create a face that can easily and efficiently be animated on stage by a puppeteer. So our modelers have different considerations than modelers simply preparing a character to be animated frame-by-frame," explains Tubiana. "Our models have to work in real-time and key-frame animation."

Therefore, one of the main differences between Medialab models and those of other houses is the way they are optimized. Using a proprietary system, Medialab technicians have developed a methodology for keeping the polygon counts of models amazingly low. This system allows for a greater number of polygons around major moving parts, such as the mouth, while streamlining the count around immobile areas like the skull. By keeping the polygon

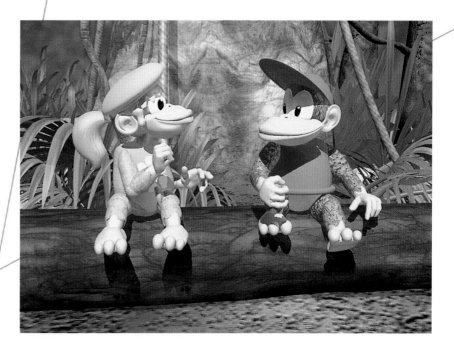

count low, it takes less time to render Medialab models—thus the ability to output feedback in real-time.

But before the models are taken to a live-action set to be animated, they are prepped. Explains Tubiana, "There are restrictions to real-time animation. We can't capture the motion of a character working with a prop yet. That's still too time consuming in a series, so we pre-animate that interaction. For example, if Donkey Kong has to pick up a coconut, it's just simpler for us to digitally key-frame that action. Also, some actions, like swinging from vines are more appropriately animated in the computer."

Once a scene is ready to go, with completed sequences cut in, the crew heads to the Medialab stage. On this set is a Silicon Graphics Onyx computer running Medialab's proprietary real-time motion capture system, Clovis PA. Movement data is transferred from a performer to this SGI machine via a Polhemus Ultratrak Pro capture system. This system includes a Motion Capture Server, a group of receivers or sensors, little white Ping-Pong balls that are placed on the performer's "suit" and an odd globe that looks like something out of an old *Star Trek* episode that serves as the systems transmitter.

The actor, or in Donkey Kong's case, the actress performing his movements, dons a suit and then waits as technicians apply the sensors to points that mirror moving parts in Donkey Kong's digital model. The sensors are attached to cables that form a bundle at the back of the suit and flow off to the Polhemus transmitter via a high speed Ethernet connection.

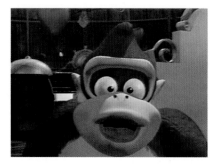

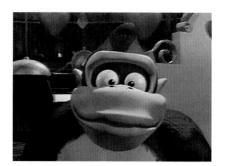

Donkey Kong's facial expressions are created in real time during performance animation sessions by a puppeteer.

Another link in this digital chain is the puppeteer who drives the facial expressions of the character. Wearing a pair of data gloves, the puppeteer moves his or her hands in much the same way he would to work a marionette, only for this work, one hand handles eyebrows and eyes while the other handles mouth moves.

When the actress moves, her gestures are applied to the animated model of Donkey Kong in real-time. This is displayed on a television monitor for the benefit of the puppeteer who matches his movements to that of the character and the words of the voice-over play back.

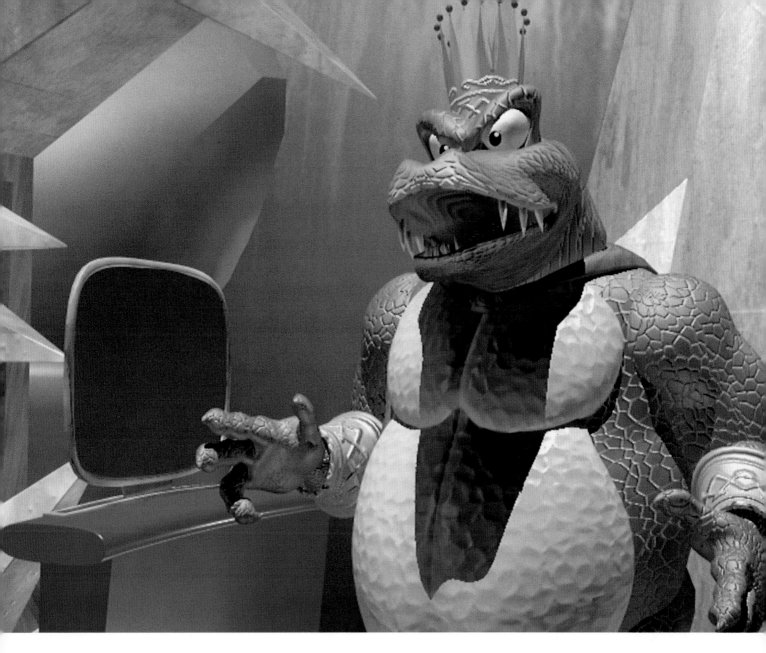

One crown not enough? King K Rool and his evil reptilian minions are out to steal Donkey Kong's crown.

The SGI machine, running the Clovis software, records the motion data as it flows in, in various levels of complexity. Movement is played back at a medium rendered level—enough detail so that the puppeteer can see what he is doing, but not so fully rendered that it won't run in real-time. After the capture session, which typically takes about eight hours, the data is cleaned up to eliminate digital noise. Then it is composited into the many exquisite backgrounds created during preproduction. The look or mood of each episode is heightened during a last rendering pass that adds final colors and lighting.

Medialab technology is certainly changing the way Hollywood looks at television production. The animated movement of most series takes six to eight weeks to produce. The character movement of one *Donkey Kong Country* episode can be completed in about two—a statistic that bodes well for the future of performance animation and computer animation in general.

Alias/Wavefront pushes Power Animator software to *the end.*

It took research and development to create the medium of computer animation and it takes research and development to keep the medium moving forward. Every computer animation house relies on it—whether to solve a sticky rendering problem or to create a brand new look. Although the processes are complex, people are still at the heart of R&D—artists and scientists who, working together, continually break impossible digital barriers to create worlds and characters that once existed only in imagination.

Research & Development

The New Frontier

This section explores the trailblazing work of four companies: two software development firms, Alias/Wavefront and Microsoft Softimage, and two independent computer houses, Lamb & Company and Pacific Data Images (better known as PDI). Each of these firms gave the reins to an individual animator or team and allowed them to take time from their regular duties to push the envelope of the art form. At Alias/Wavefront, Chris Landreth set out to test the company's new software and ended up creating an intriguing parody that earned an Academy Award nomination. Microsoft researcher Charlotte Davies took the hard-edged genre of virtual reality and evolved it into Osmose, a virtual-reality experience that brings the player on a spiritual journey. Larry Lamb's animation team pushed the limits of motion capture technology to see how live actors could add depth to the performances of CG characters. And, in an effort to prove that computer animation is more than flying logos and cold, hard surfaces, PDI's Raman Hui has created two dynamic shorts that are winning acclaim in film festivals around the world.

The results of these experiments into photorealistic detail, virtual reality, and character animation have opened doors to the future—a future where computer animation may well become the most popular form of entertainment.

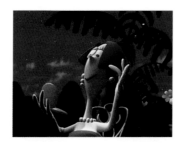

PDI wakes up the industry with *The Sleepy Guy.*

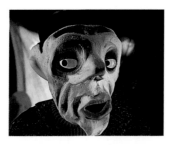

Lamb & Company brings a theatrical twist to motion capture.

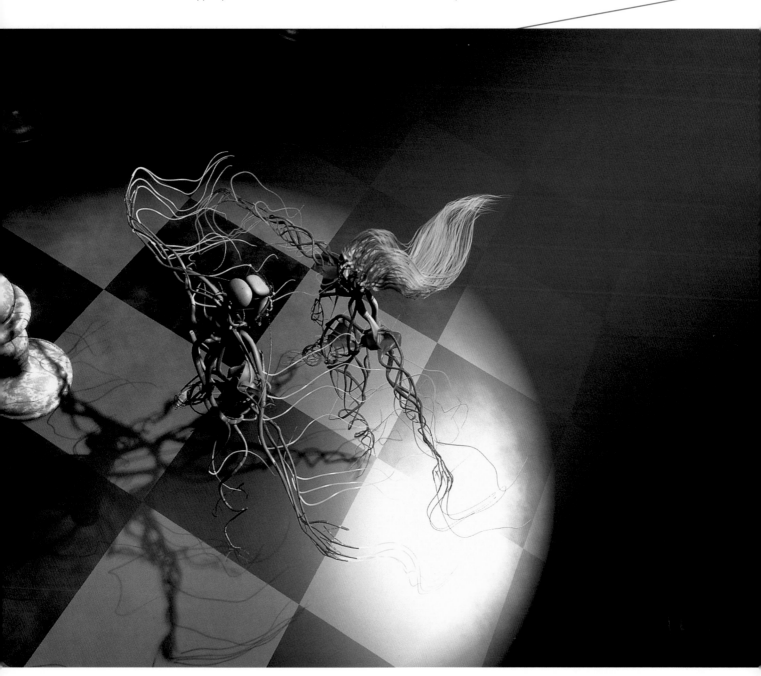

Softimage

Osmose

The journey to produce *Osmose* began, appropriately enough, inside the mind of Charlotte Davies, director of Visual Research for the computer animation software development firm, Softimage (Microsoft). As a fine artist she spent years exploring the representation of what she describes as "the subjectively experienced, enveloping and luminous quality of physical space." However, as a painter, she felt increasingly restricted by the two-dimensionality of the medium.

In the late 1980s, Davies joined Softimage in order to learn more about computer technology. There she continued her visual experimentation on the computer, recreating her complex painterly esthetic in the 3-D realm. "But ironically," she says, "I again felt limited by the two-dimensionality of the medium. Images created with 3-D software were still just photos. The 2-D picture plane was a barrier to experiencing the enveloping depth in my work." To construct a space that would embrace the viewer, she turned to immersive virtual environments. Her fascination with virtual applications led to the creation of *Osmose*, an artistic masterwork that completely embraces the viewer.

Davies began preproduction at Softimage in the fall of 1993 by writing down her theories concerning enveloping space and defining how the creation of *Osmose* could be realized. By year end, she had a

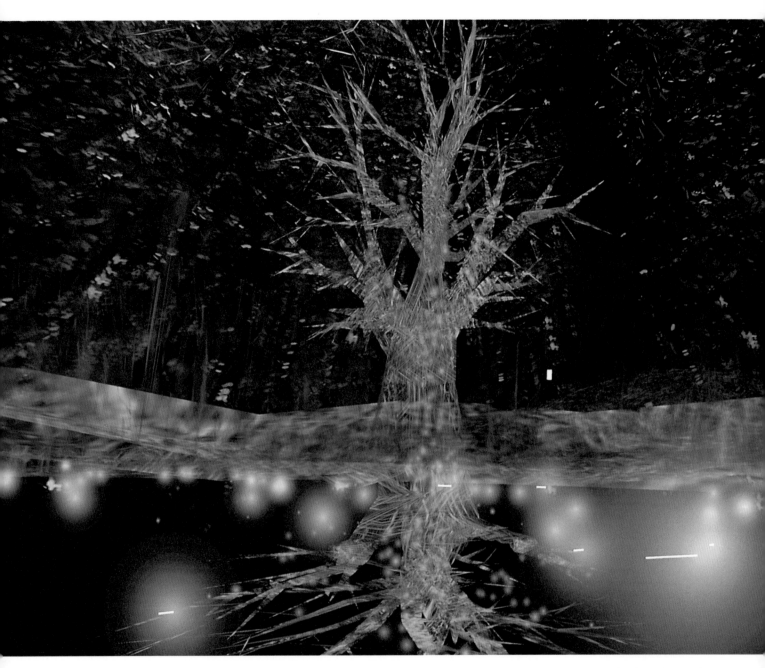

twenty-five-page treatise that would serve as an esthetic guideline to the "philosophical, esthetic, interactive, and content related objectives" of *Osmose*.

Next she gathered her production team. John Harrison was brought on board from the Banff Center of the Arts to handle software development and Georges Mauro, a Softimage animator, was tapped to create models, animations, and textures.

Together the threesome set to work on what would prove to be a very organic production. Davies based her production process on her methodologies for painting, systematically avoiding restrictive techniques such as the storyboard. "I believed creating a storyboard would limit the work—reduce it to illustrating prior concepts," she says.

"... by changing space, by leaving the space of one's usual sensibilities, one enters into communication with a space that is physically innovating For we do not change place, we change our nature."—Gaston Bachelard, *The Poetics of Space*

WHAT IS *OSMOSE*?

Osmose is an immersive virtual environment, a solitary area where a single visitor can enter its "worlds" by donning a stereoscopic head-mounted display with 3-D localized sound and a motion tracking vest. The immersion chamber is separated from the audience by walls and a back-lit screen through which visitors can watch the immersant in silhouette. Visitors can also follow the participant's journey as it is projected on a screen opposite the immersant chamber.

Immersants in *Osmose* float like scuba divers. The tracking vest measures chest expansion as he or she breathes, as well as the position and movements of the spine. To move forward or back, the immersant tilts the upper body forward or back. To move left or right, the immersant leans to the left or right. To rise or float, the immersant breathes in. To sink or descend, the immersant breathes out.

The first "world" the immersant enters is a Cartesian Grid that serves as an orientation space for the experience. With the immersant's first breaths the grid dissolves, leaving the participant in a forest clearing where an "Archetypal Tree" looms as the central metaphor. The tree and the pond that glows beside its roots serve as a sort of "home base" for the traveler. The clearing is surrounded by a forest that can be entered by leaning toward the horizontal plane. The immersant can also enter the tree, rising through its branches or swimming down into its roots.

By exhaling, participants descend into the Subterranean Earth. If the immersant descends into the pond, he or she can go into an Abyss from which it is possible to re-enter the world above by passing through a symbolic Lifeworld—a metaphor that transforms into the central clearing.

Except for the grid entry and the ending, immersants may journey through *Osmose*'s worlds in any order.

The sounds of *Osmose* were created by digitally sampling voices of a man and a woman. "This was done," explains Davies, "as a means to re-affirm the presence of the human body in virtual space."

After fifteen minutes, an attendant working at a keyboard gently takes the voyager through the ending, another version of the Lifeworld.

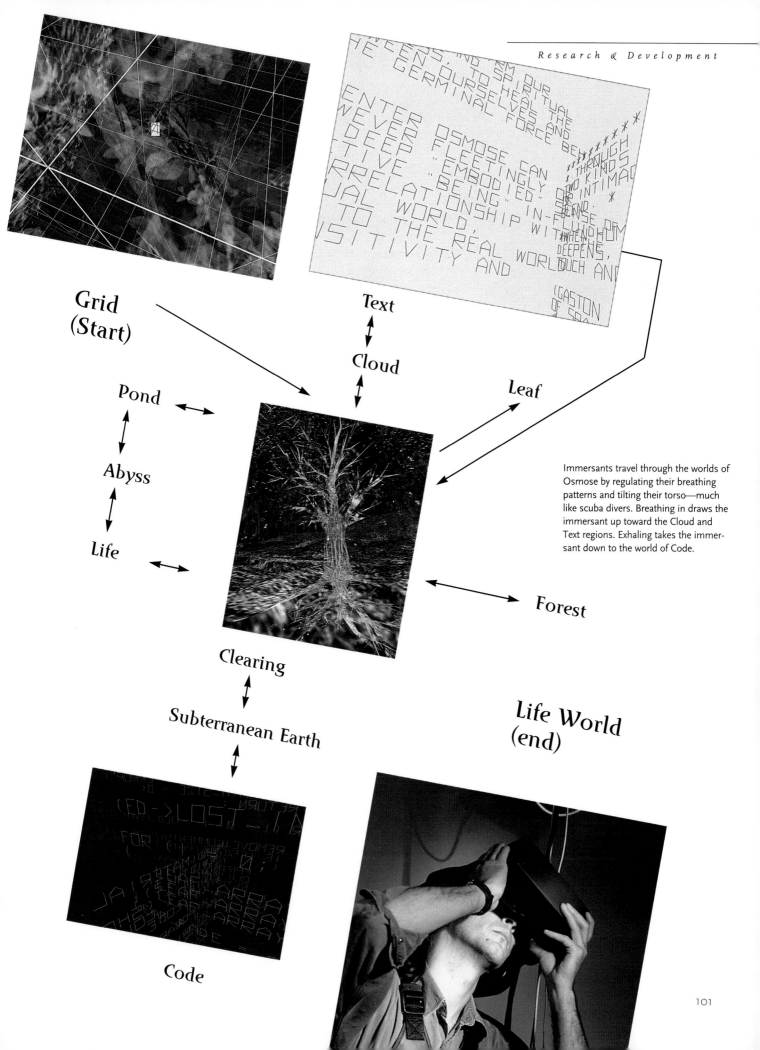

Grid (Start)

Text

Cloud

Leaf

Pond

Abyss

Life

Immersants travel through the worlds of Osmose by regulating their breathing patterns and tilting their torso—much like scuba divers. Breathing in draws the immersant up toward the Cloud and Text regions. Exhaling takes the immersant down to the world of Code.

Forest

Clearing

Subterranean Earth

Life World (end)

Code

The team's first technical challenge was figuring out how to animate the complex esthetics of *Osmose* in real-time—or one frame output every 1/30th of a second. To emulate Davies' digital still images would be impossible. Due to her complex use of transparency and light, some of her pieces took longer than forty hours to render.

So Harrison and Mauro began by attempting to render an equivalent Davies' esthetic in real-time. This meant working extensively with transparency techniques and semi-transparent texture maps in order to dissolve distinctions between objects and the space surrounding them. The effect, multiplicities of semi-transparent form, helped build the "perceptual ambiguity" that was essential to Davies' thematic research—that of creating an evocative rather than illustrative work. Some of the models, like the tree in the clearing, were then given more recognizable features so that an immersant could "home" into them and feel grounded. However, many elements consisted of only vertical strokes or luminous flecks suggesting, for example, the appearance of a forest edge or the luminous fullness of the sky.

An immersant experiences
the primeval forces of the
Subterranean World.

This immersion chamber is separated from the audience by walls and a backlit screen through which visitors can watch the immersant's movements in silhouette. Visitors can also follow the journey as it is projected on a video screen opposite the chamber, accompanied by live sound generated by the immersant's behavior within the *Osmose* space.

To animate, Harrison built a particle system, which was inherently fast to render in real-time. Mauro then created splines in Softimage that were used as paths for the particles to travel on. Other tasks involved porting the Softimage object models to descriptions optimized for real-time performance in the hardware used to run *Osmose*, a Silicon Graphics Inifinite Reality Onyx. By manipulating the Z-Buffer on this piece of hardware, Harrison created further spatial ambiguities between representations of foreground and background. Much like an Escher print, distant objects in *Osmose* sometimes appear to move through objects close at hand, effectively counteracting convensional Cartesian notions of space.

To create the illusion of three-dimensional space generated in real-time according to the actions of the immersant, Harrison wrote some 20,000 lines of original programming code. "This code handles the reading of various virtual reality devices, working out what to draw for each frame based on where the immersant is looking, altering the environment according to the immersant's position, and rendering the views of the space to give a true sense of 3-D," explains Harrison. All of his code is contained in the Code World of *Osmose*.

Explaining her intentions, Davies says: "I developed *Osmose* not only as an 'artistic' work, but as a prototype for an alternative approach to the design of immersive virtual environments, in terms of visual esthetics and interactive sensibility. In contrast to the literally representational 'hard-edged-objects-in-empty-space' of conventional 3-D computer graphics, the *Osmose* esthetic strives for perceptual ambiguity and dissolution of subject/object, figure/ground dichotomies, as a means of breaking down the Cartesian 'split' and actively engaging the mind of the immersant. While conventional approaches to VR or interactive games tend to rely on hard-oriented methods such as joystick, wand, or trackball—all of which tend to support a disembodied and distant stance towards the world—in *Osmose*, we used an 'embodied' interface, relying on breath and balance. This effectively brings the experience inward, grounding it in the core of the immersant's own body. This approach was intended to re-affirm the role of the subjective experience, the 'felt' body in cyberspace, in contrast to its usual absence or objectification in virtual worlds.

(Left) If the immersant inhales, he or she ascends through a level of Clouds into a world of Text, consisting of excerpts from Davies' theoretical writings as well as the works of relevant philosophers and poets. (Right) In the Clearing, if the immersant exhales deeply, he or she will pass through the Subterranean Earth to the Code World, consisting of twenty-thousand lines of software code, glowing green against black space.

Osmose's process-based production required constant communication collaboration, and a great deal of trial and error. "Throughout the project, as a means of communicating to John and Georges what I envisioned, I had to make all kinds of maps and charts to explain the relationships of the parts—or worlds—to the whole in terms of both space and time," says Davies. "We spent nearly seven months developing the visual vocabulary, doing tests and so on. Once we were able to put on the helmet and the vest and get "inside" *Osmose*, the work went much faster. Then the production became less conceptual and much more experimental and interactive—more like painting in a way— because we would change things on the fly as we responded "in situ" with our minds and bodies to the environments we were creating."

With the completion of *Osmose*, Davies' goal—to construct an artistic "enveloping and embodied space"—was realized. And if art can be measured by how much it affects its audience, then Davies has certainly created it. Many immersants are deeply moved by the experience: many emerge speechless and some have even cried with a sense of loss.

Lamb & Company

Huzzah—Babaloo the Beast Boy

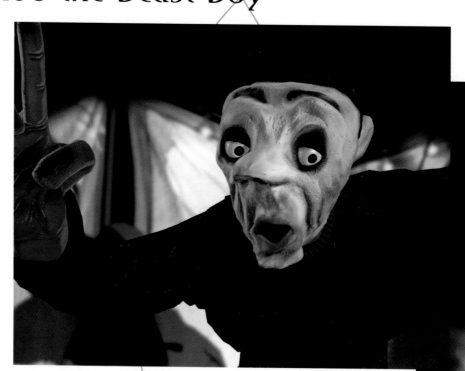

Larry Lamb, founder and president of Lamb & Company, had a theory he wanted to prove. "To produce long formats such as television series and features you need a large group of very talented animators—specifically animators who can act," explains Lamb. (Acting in animation refers to an artist's ability to draw believable gestures and movements.) "Right now the number of animated properties waiting to be produced exceeds the number of individuals in the talent pool with this particular talent. So I thought why not start to draw from a larger pool—actors. But first we had to prove that the subtleties of an actor's craft—the portrayal of emotions through gesture—could actually be captured."

To do this, Lamb decided to animate a short with Kevin Kling, a local playwright, storyteller (he is often heard on National Public Radio's "All Things Considered"), musician, and actor. Intrigued, Kling accepted the challenge and began work on an unusual monologue that would truly test Lamb & Company's ability to capture and animate the emotional palette of a stage actor.

Both Lamb and Kling agreed that the animation they would create should also have a "theatrical" feel, something completely different from Saturday morning cartoons. So Kling dug into his bag of tricks and came up with two rather spooky elements

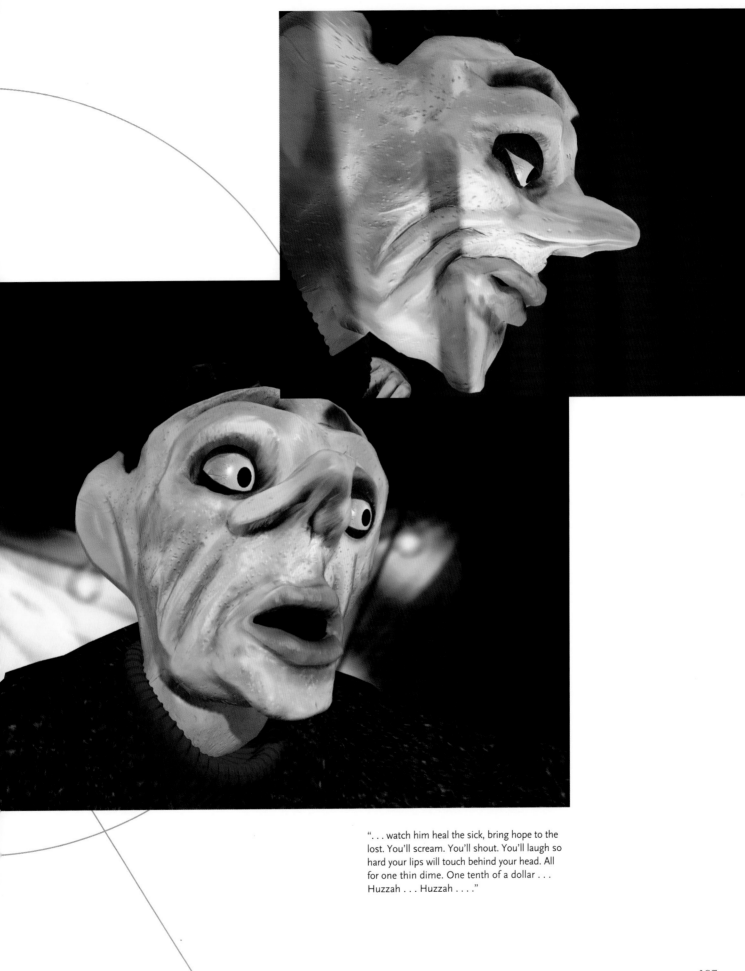

". . . watch him heal the sick, bring hope to the
lost. You'll scream. You'll shout. You'll laugh so
hard your lips will touch behind your head. All
for one thin dime. One tenth of a dollar . . .
Huzzah . . . Huzzah"

The Barker character in *Huzzah* is based on a wooden puppet carved by actor Michael Sommers named Darren. The combination of motion capture and computer animation gave him life without strings.

THE CREATION OF *HUZZAH*

To create the digital character model, Lamb & Company artists scanned this puppet carved by performance artist, Michael Sommers. When Sommers sculpted Darren, he gave him an asymmetrical face. One side is, as he puts it, "weirdly happy" while the other is "aghast." Watching this misshapen face come alive through the magic of computer animation is a chilling experience for audiences who find themselves both repelled and intrigued. During the production of the short, Darren remained at Lamb & Company, hustled between the modelers and animators' offices, hanging on a coat hanger. "It was as if," says Chris Immroth, "we had a little spirit in our midst."

The Story

The short opens on a carnival barker, dismally holding a tin cup, trying to catch drops of rain as they leak through his old circus tent. When he has a mouthful, he kneels by a hole in the floorboards and lowers the cup down to the unseen creature below. He sings gently to the creature then rises to begin his evening rhapsody—the crier's longwinded, almost poetical billing of the freak. "Step right up! One thin dime. One tenth of a dollar! See the amazing Babaloo, the Beast Boy from Borneo. All real! All live. Hair covers 95 percent, that's right 95 percent of his body. . . . "

Animation director Susan Van Baerle explains that Darren's body and face were digitally scanned to form a computer model for animation.

upon which to base his monologue—a sinister play and a gruesome, yet engaging, puppet.

The premise for the monologue came from "Lloyd's Prayer," a play Kling wrote about a con man who finds a child raised by raccoons and turns the innocent into a freak at a carnival show. Kling enhanced this concept by turning the character of the con man into a barker at a carnival who loves his unseen pet, Babaloo, the Beast Boy, yet stoops each night to selling the beast's frightening looks to the public for "one thin dime, one tenth of a dollar."

The barker's character design came from a puppet that Kling uses during appearances of his performance trio, Bad Jazz. Darren, as the puppet was named by his carver and fellow Bad Jazz member, Michael Sommers, became the model for the computer-animated version of the barker.

To recreate Darren in the digital realm, Lamb artists placed Darren on a pedestal and, like some strange scene in a *Star Trek* episode, strapped the little fellow down and scanned him (rather, digitally recorded the landscape of his body). To do this a grid work of thin tape was applied, section-by-section to the puppet. Then each section, such as a leg or arm, was digitized by pressing a stylus from a scanning apparatus against the intersecting points of the grid. The points of each section showed up in Lamb's Motion Management software as elements of a wireframe character. Much like a rag doll, these points were then digitally "sewn" together to build the full model.

One of the more trying challenges of the model creation was building the head and face. Although Darren's head could be quickly recreated in the computer via scanning, the functions for moving his facial features had to be generated from scratch. On a low resolution version of the face, head modeler Jim Russell, applied over sixty different controls, combinations of

On the motion capture set, actor Kevin Kling suits up for work. Assistants help him apply delicate sensors that will record his body and hand movements.

"There was a moment when I knew our software really worked—really was able to capture the complexities of human emotion. And that was that little period of time between when the cameras and all the equipment are up to speed and the director calls 'action.' During those few moments, I think we got some of our most frighteningly real data, because the actor wasn't really performing yet, just being himself. And, to be able to catch that subtlety . . . that was scary!"—*Scott Gaff, technical director*

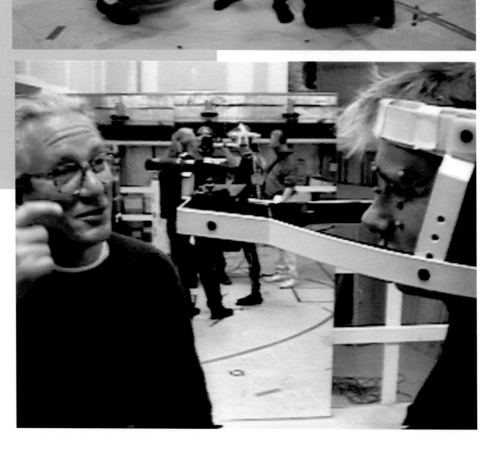

Director Larry Lamb checks out the head-mounted capture system. Kling tries to relax and feel comfortable, even though he has more than a dozen markers glued to his face.

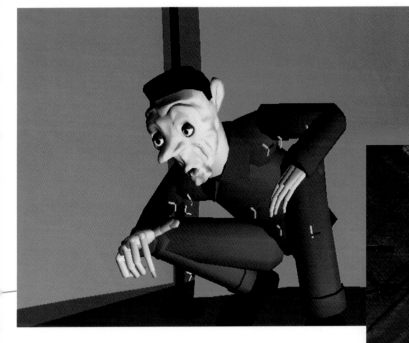

Will a model actually hold up when it's animated? Sometimes holes appear in unlikely places and have to be patched before a final rendering run. This model appears to hold up fine.

which created an almost infinite number of expressions for the digital Darren.

Says Russell, "Because we'd never tried to create a fantasy character that was this human, the creation of Darren was a real learning process. I spent a lot of time experimenting with controls and combinations of controls and then making revisions. In the end, I went for very localized motion—not trying to do too much with any particular control, allowing small movements to tell the story— like the corner or an edge of an eyebrow moving up and down."

While Russell worked on the model, head of software development, Jeff Thingvold worked to create a motion capture system that could record Kling's entire performance. In the past, Lamb—and every capture house on the planet—had settled for capturing movement in pieces. For instance, one actor would don a helmet that would record facial movement, while another actor performed the "voice" and another, wearing a body tracking suit, performed the physical gestures. Typically the movements of the hands were added in during another pass by yet another performer wearing tracking gloves.

Needless to say, no matter how a company chose to put this capture puzzle together, it always resulted in a fragmented version of a live per-

formance. No system ever truly captured a performer's real intent—which was the very thing Lamb wanted most to prove possible during the creation of "Huzzah." So Thingvold pushed the capabilities of the in-house proprietary recording system, Lambsoft©, and the abilities of their three tracking systems to the limit!

Thingvold found that the process of connecting the three systems—facial, body, and hand—was relatively simple. His biggest challenge was finding a way to record the massive amount of data coming in from these sources simultaneously. To solve this problem he wrote a small piece of work-horse software that, much like a worker on an assembly line, talked to the data, time-stamped it, and then filed it away for future decoding.

Says Thingvold, "When 'action' is called on our set, our little program talks to all the tracking equipment and asks for data. Then all the equipment starts to stream back information which this program time-stamps. And, mind you, all of this has to happen in a very short period of time. In fact, this little program has to sample fifty-five pieces of information every second. So the hardest part of the production process for me was getting this piece of software to run fast enough." To do this, Thingvold applied years of programming experience and good old trial and error.

With Jeff Thingvold's specially designed system, head, hand, and body sensors captured all the actor's gestures. In the past, these three components were captured simultaneously but by separate performers working in sync.

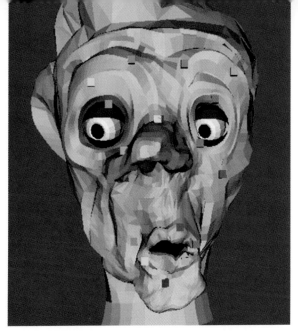

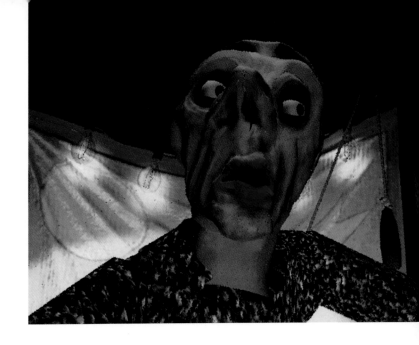

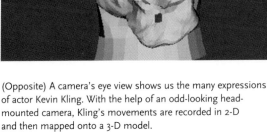

(Opposite) A camera's eye view shows us the many expressions of actor Kevin Kling. With the help of an odd-looking head-mounted camera, Kling's movements are recorded in 2-D and then mapped onto a 3-D model.

By the time the character model and software systems were in place, the script was completed. The stage was literally set for the digital recording sessions to begin. On the morning of the first shoot, Kling was introduced to the various apparatuses he had to wear—dozens of tracking markers on the moving parts of his face, a helmet with a camera mount extended about a foot and a half from his face, gloves, and a suit. By the time he was fully suited, he looked and felt a little like an alien with an umbilical cord stuck to a computer.

Needless to say, as is true with every newcomer, it took quite a few rehearsals for Kling to adjust to the world of motion capture. Says Kling, "Everything you are, everything you do, gets bigger in terms of the animation. I had to realize that my hands were bigger, my feet, all my gestures. So I didn't want to waste as much movement as I would on stage. It really made me focus my performance and refine it quickly in order to get the take."

In addition to the data recording software, a separate "polling program" ran during each take, recording only five samples a second. This simpler data set was applied in real-time to a low-res model of Darren so that both Kling and director Lamb could see the results of his performance. With each take, notes were given and adjustments were made. After three half days of shooting, Lamb had the takes he needed.

The Barker's oddly modeled face mirrors that of his puppet reference. Like the popular symbols for comedy and drama, one side of his face is whimsical, the other is sad.

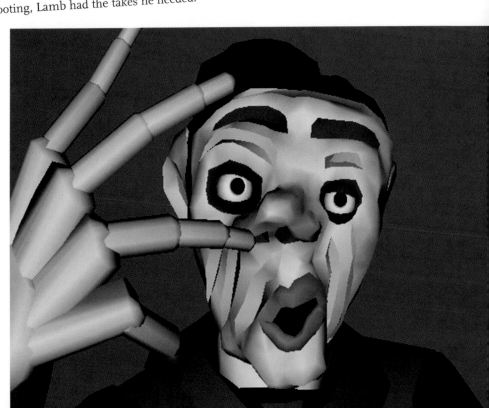

After the session, another team headed by animation director Susan Van Baerle used the Lamb Motion Management software to clean up digital noise and then enhance the animation. Says Van Baerle, "Mapping the captured motion onto our model was the most laborious part of the process. Basically you have to look at a long list of data and figure out which parts of the list refer to which parts of the character's body. Then you take out all the spikes, or noise—you usually get noise when the trackers get too close to the camera or too far away. For *Huzzah*, the gloves had a lot of noise."

Since tracking markers could not be placed on the eyes of the character Van Baerle animated the movements of Darren's eyes. After all the animation was completed or refined, it was rendered with skin and clothing textures created by Jim Russell. "These were basically our interpretations of the puppet, which were definitely not smooth surfaces" says Russell. "To create the look we wanted, we painted textures in digital paint programs then applied them to the surface of the model. We also created a few displacement maps so that the surface would have a rough texture, like sandpaper."

Once all the pieces were completed they were brought into Pixar's RenderMan™ software for rendering and then output to film. Since the completion of the short, Lamb & Company has been invited to screen it at film festivals around the world, proving that skilled traditional animators are no longer the only artists

The Barker speaks to the empty night sky and an audience that may never arrive.

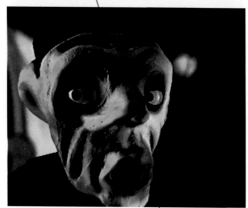

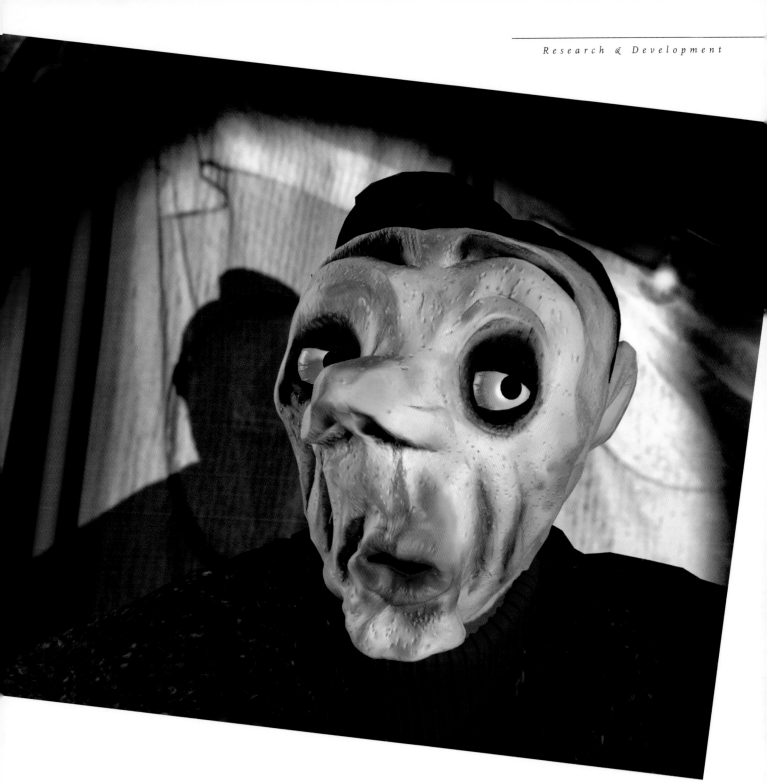

able to recreate human emotions frame-by-frame. Now, a good director with a skilled team of programmers and computer animators, along with one fine performer can make a new type of art—one that is a remarkable amalgam of live theater, recorded film, and hand animation—that, like a living photograph, recreates the human experience.

The pathos of life reflects in the face of the Barker, proving that computer animation can truly touch heart and soul.

115

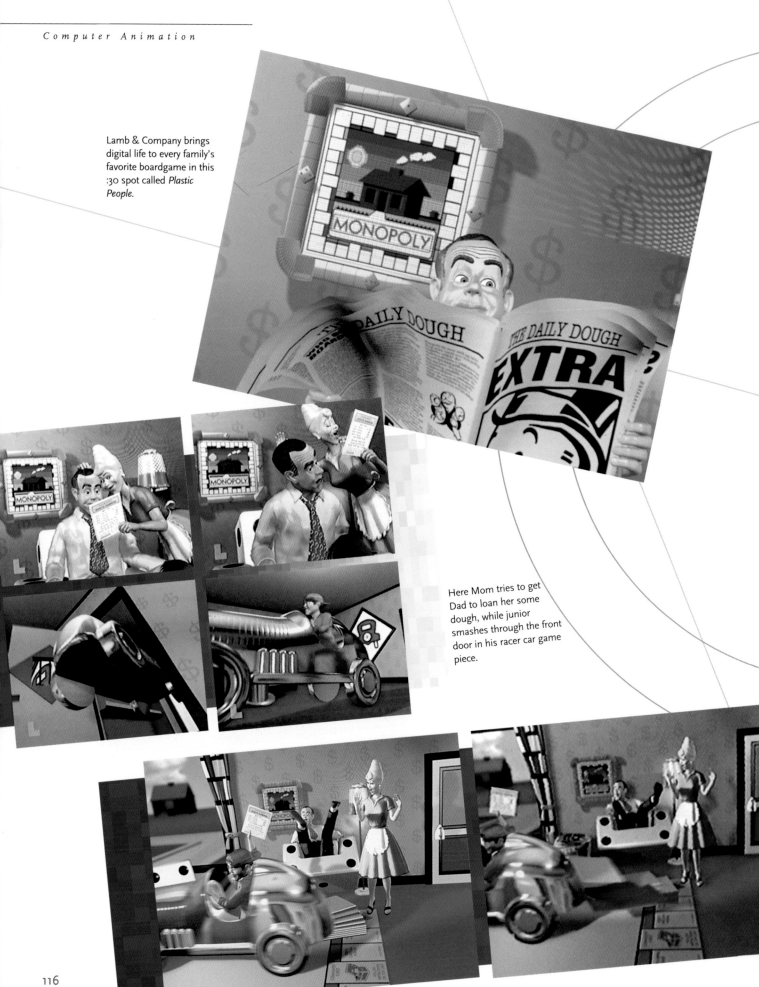

Lamb & Company brings digital life to every family's favorite boardgame in this :30 spot called *Plastic People*.

Here Mom tries to get Dad to loan her some dough, while junior smashes through the front door in his racer car game piece.

Lamb & Company
Gallery

Plastic People shows off Lamb & Company's ability to create realistic human movement under the tight deadlines of the commerical industry.

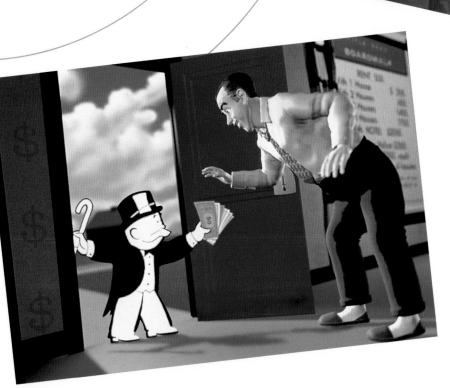

The Monopoly Man brings Dad the good news, a $100 inheritance.

SLEEPY

Pacific Data Images
The Short Films of Raman Hui

When animator Raman Hui isn't working on a PDI project, he's working on an animated short of his own. His first work, *Sleepy Guy*, started out as a series of sketches in his journal (this and facing page).

Eight years ago, when Raman Hui walked through the doors of Pacific Data Images, he felt he'd found a kindred spirit. PDI was dedicated to the very thing that intrigued Hui the most—the creation of believable, lovable characters out of cold digital code.

So enthused was Hui with his new home that he started his own research and development project, the production of a short called *Lazy Guy*. With an okay from management and a generous support of resources, the stage was set for Hui to take computer character animation into the world of gags and slapstick.

"In the beginning, my idea was to do something different with the computer. Since I come from a traditional animation background, I thought why not try to bring some of that cool, fun, cartoony look into the computer realm—to help prove that computer animation isn't cold. But," says Hui with a smile and a sigh, "it took me an awfully long time."

Hui's shorts always start out as simple ideas, but as he starts to work on them they become much more elaborate.

Hui worked on *Lazy Guy* after hours and on weekends for three grueling, but memorable, years. Part of the reason the short took so long to complete was that Hui couldn't seem to leave well enough alone. To fully develop his funny character, he had to tell a story with a beginning, middle, and an end—something that's pretty hard to do in a one- or two-minute format.

Says Hui, "*Lazy Guy* started out as a little skit about this guy who doesn't have much to do on a Sunday afternoon. Then I kept adding to it and adding to it, until it became *Sleepy Guy*, a story about a guy who has this great dream but, because of things that keep happening in his bedroom, can't stay asleep to dream it."

To create the Sleepy Guy character Hui started by sketching in his journal. After he had a design he liked, he put his plot ideas down on paper in the form of a loose storyboard. While hammering out the twists and turns of his little comedy, Hui took his 2-D sketches and used them as a base to model Sleepy Guy in the 3-D realm.

The mission for *Sleepy Guy* was to create a sympathetic character that looked warm and lovable—even after he was translated to the digital realm.

Character development begins with
pencil drawings.

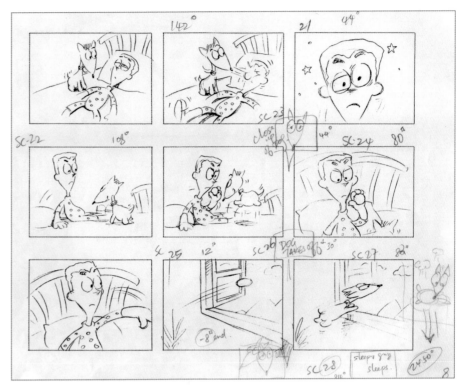

Hui tries to stick to a formal storyboard when ani-
mating a short. However, notice the wacky doodles
that represent additional gags.

To save computing time, animation begins with
wire frames. Detail is added as timing is approved.

"I started out by sculpting Sleepy Guy in clay," explains Hui. "That helped me understand what
he would look like when I actually built him again in the computer. Once I understood how all his
joints connected and really got a handle on his basic shape, I started to model him digitally. In order
to get a jump start on that process, I used the technical set-up of a character PDI animates for com-
mercials, the Pillsbury Doughboy."

Using the Doughboy "script," or programming formula, put Hui a few steps ahead in the pro-
duction process, but he still had to do some tinkering. "The Doughboy model gave me a lot of the
basic movement controls and joints that I needed, but it didn't give me the exact shape. Sleepy Guy
is obviously much skinner and taller than Doughboy, so I had to do a lot of tweaking and fine-tun-
ing—in other words, rewriting a lot of code. I don't have a computer background, but I've learned
a lot about programming since I've been here, so that fortunately wasn't a big problem. In fact, I've
always been good at math, so programming is sort of fun for me."

Once Hui was satisfied with his digital model, he tested it. By animating a few short movement
sequences he was able to see the areas—typically around the joints—that needed improvement.

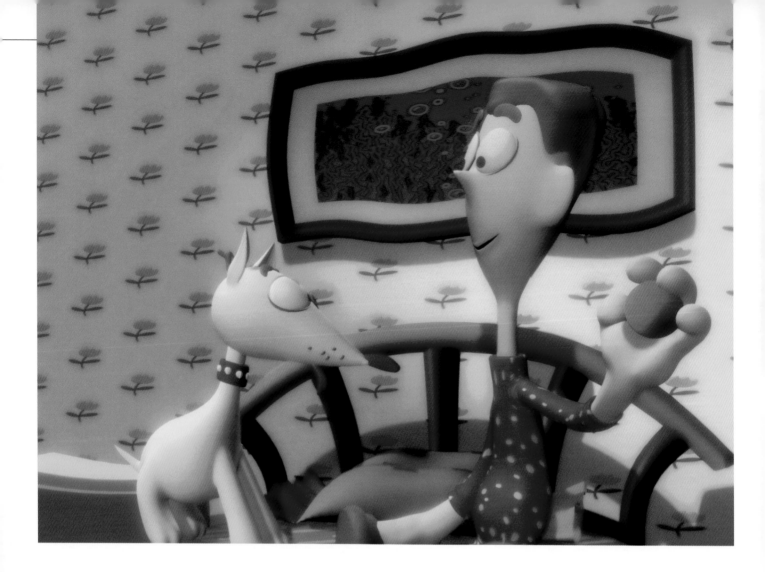

In the next shot sequence, Sleepy Guy throws a ball out an open upper-story window. His faithful, yet very annoying dog chases right after it.

After the model passed muster, Hui started to build the other characters—the dog and the woman—and the array of backgrounds and props he would need to make Sleepy Guy's environment appear believable.

Adds Hui, "Because it takes so much stuff to make a room look real, the props were a real challenge—really time consuming. And once I built them I had to spend a lot of time figuring out the right places to put them."

When Hui had all his characters and set pieces completed, he was ready to begin animation. Here he ran up against two typical, and once again, time-consuming challenges—animating the faces of his characters and animating characters interacting.

To create facial expressions he devised twenty different movement paths, each containing links of six to eight controls. Linked controls could move an eyebrow, for instance, in a certain manner—up for surprise or down to show consternation. The controls, in turn, were linked to a path that could move an eye and an eyebrow together to build an expression. All told, the combination of controls and paths gave him approximately one hundred different expressions for Sleepy Guy's face—in other words, a heck of a lot of character for such a simple guy! The same set-up was created for Sleepy Guy's girlfriend, with a simpler model applied to his little dog.

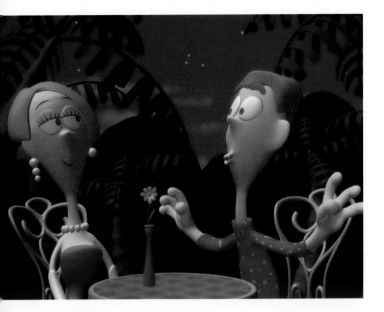

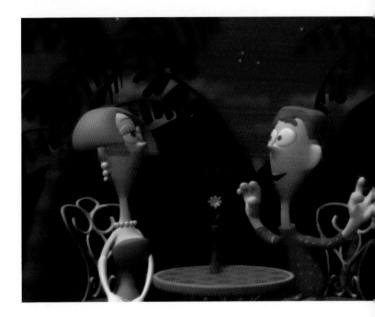

Scenes that included shots of Sleepy Guy and his girlfriend required some inspired guesswork. Says Hui, "With hand-drawn animation, it's no trouble to have two characters in the same scene—you just draw them in. With computer animation you can animate them together but it takes a lot of computing power, so the process is painfully slow. It's easier to animate one first—like the character that leads the action—save that, and then go back and do what we call a calculation of the animation with the motion you've done— just a simple animation of the lead as a reference for the other character's animation. Then you render the scene and see if they fit together. You can get pretty close, but you always have to go back and make adjustments."

Hui put in some long hours manipulating the movements of Sleepy Guy so that they appeared smooth and pliable (like a bendable, plastic doll) rather than hard and stiff—a characteristic he found annoying in a great deal of computer animation at the time.

In his dreams, Sleepy Guy tries to make a good impression on his girlfriend in the hopes of stealing the perfect kiss.

123

SLEEPY GUY STORY

Like any cartoon starring Donald Duck or Bugs Bunny, *Sleepy Guy* opens with the hero at peace, but he's suddenly disturbed by a random element that he cannot control.

Sleepy Guy is dreaming of his girlfriend. He finds her seated at a table for two in a romantic glade. The moon is shining as she puckers up for a big kiss. Sleepy Guy is in heaven . . . for about half a second. His dream kiss is interrupted by a red ball falling from the clear night sky. Sleepy Guy looks up in dismay only to have another ball and another, bop him on the noggin. This brings him back to reality—his bedroom and his trusty dog throwing a slobbery ball on his face—over and over again.

Irritated, Sleepy Guy plays a not-so-nice game of fetch, by throwing the ball out his open upper-story window. Of course the dog chases the ball out the window, leaving behind a pitiful yelp and puff of smoke. Sleepy Guy lays down and returns to his garden paradise. But before he can sweep his intended into his arms, an alarm clock appears on the table. Sleepy Guy tries covering it with his hands, pounding on it, even sitting on it. But the clock gets bigger and louder until it rises up like a skyscraper. When the clapper rings, it takes him with it, banging him back and forth between the bells. He finally wakes, his eyes bouncing back and forth in his head, to destroy the ringing alarm on his nightstand.

In an effort to spend some quality time with his honey, Sleepy Guy swallows sleeping pills. Now he has his dream to himself. But, just as their lips touch, her face begins to mutate. She sprouts a snout and fangs and pointy little ears. Instead of a wondrous soft kiss, she licks his face. As the short ends, the camera returns to reality—Sleepy Guy conked out on his bed, his dog licking his face.

The vibrant colors and soft edges apparent in *Sleepy Guy* were a deliberate attempt to bring the warmer world of traditional animation into the digital domain.

After the animation was complete, Hui worked with PDI technical director Michael Collery to light the scenes and create the textures (skin, fabric, fur, etc.) of the characters, backgrounds, and props. Says Collery, "We were trying for a painterly artistic look—something like an oil painting. That's fairly easy to create digitally for a still image, but for a moving image, in terms of continuity between frames—that sort of thing ends up looking like ripple glass or like you're looking at something through a screen."

Collery's solution was to simply take the edge off of any element with a hard edge by gradating the color around it. So, a flat wall with a flat paint look became warmer or fuller anywhere it connected to another wall or in areas where a prop, such as a picture, was placed on top of it. The same approach was used for characters, giving them a fuller, softer appearance.

Elements such as motion blur, shadow, colors, and camera depth were added in a final rendering pass. After this last process was completed, Hui still went back and made corrections. Often the preprogrammed creation of the painterly style made dark areas on a character's face that had to be lightened up or overly bright areas that had to be darkened. And even though the rendering script created the exact amount of motion blur it was programmed to, it often looked overdone to the human eye and had to be toned down.

After all the tweaking and futzing was through, *Sleepy Guy* woke up and came to life. He was immediately shipped to film festivals and computer trade shows around the world as an inspiration to up-and-comers—a clear message that character creation can be taken to a whole new level by animators who happen to have the kind of inspiration, talent, and staying power of Raman Hui.

FAT CAT

Industrious Raman Hui is at it again, experimenting with a watercolor look and a storybook character. "I really did have a great time making *Sleepy Guy*," admits Raman Hui. "So I thought, I'll do something again, but this time I really would keep it short, just something fast and simple. But nothing is ever fast and simple in animation—especially computer animation. Now my funny little story about a fat cat on a diet is about three and a half minutes long."

Part of the reason *Fat Cat* has gotten longer is the approach Hui has taken to creating it. With *Sleepy Guy*, he carefully storyboarded every shot before animating. With *Fat Cat* he is taking a more improvisational tack.

With *Fat Cat*, Hui brings the illustrative look of children's books to computer animation.

Hui packs a ton of personality into this little round ball of fur. In *Fat Cat*, our feline hero would gladly give up all nine of his lives if they help get his paws on a snack.

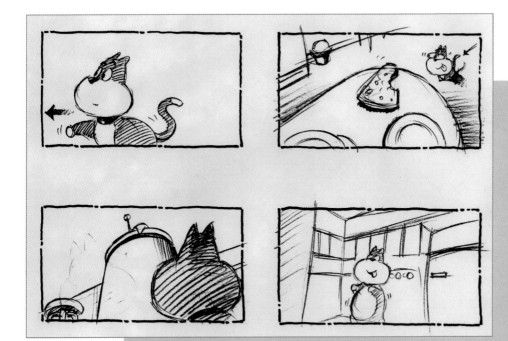

"I've been letting the character take me into the story," explains Hui. "I animate a shot and if it turns out to be something interesting, I put that in the storyboard—instead of the other way around. Sort of like performing a play without rehearsing, just letting the story flow wherever it wants."

Senior technical director Karen Schneider Brodine (along with R&D staffer Dan Wexler) is helping Hui create the model for Fat Cat and has already solved some rather interesting problems. Since Hui did not want to cover the cat with fur—he was going for a more illustrative look—she had to come up with a new kind of surface for the character. Explains Schneider Brodine, "Instead of using polygonal shapes to represent each little hair in a cat's fur coat, we used 'surface data' that told the renderer how the entire surface—rather than a collection of shapes—should look."

Modeling the deformations underneath the cat's skin—all the muscle movements and bulges of fat—was also a challenge to set up. "In one scene," says Schneider Brodine, "Fat Cat sits down on his rump and his belly hangs over his lap and flops on the floor like a sack of flour. I had to write a special deformation script just to get that shot to look right—to make his belly heavy and jiggly enough."

Look for *Fat Cat* at animation film festivals by late 1998.

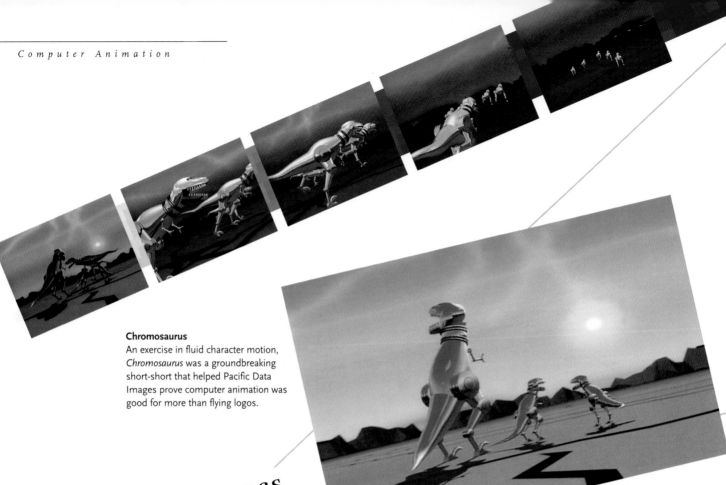

Chromosaurus
An exercise in fluid character motion, *Chromosaurus* was a groundbreaking short-short that helped Pacific Data Images prove computer animation was good for more than flying logos.

Pacific Data Images
Gallery

Bric-a-Brac
Although *Bric-a-Brac* looks like a traditionally animated cartoon, no pencils were used to make this strictly digital creation.

Opera Industriel
In this short-short, highly realistic backgrounds create an oppressive mood. Faceless slave robots, working in an enormous factory setting, portray feelings of hopelessness through subtle head and shoulder movements.

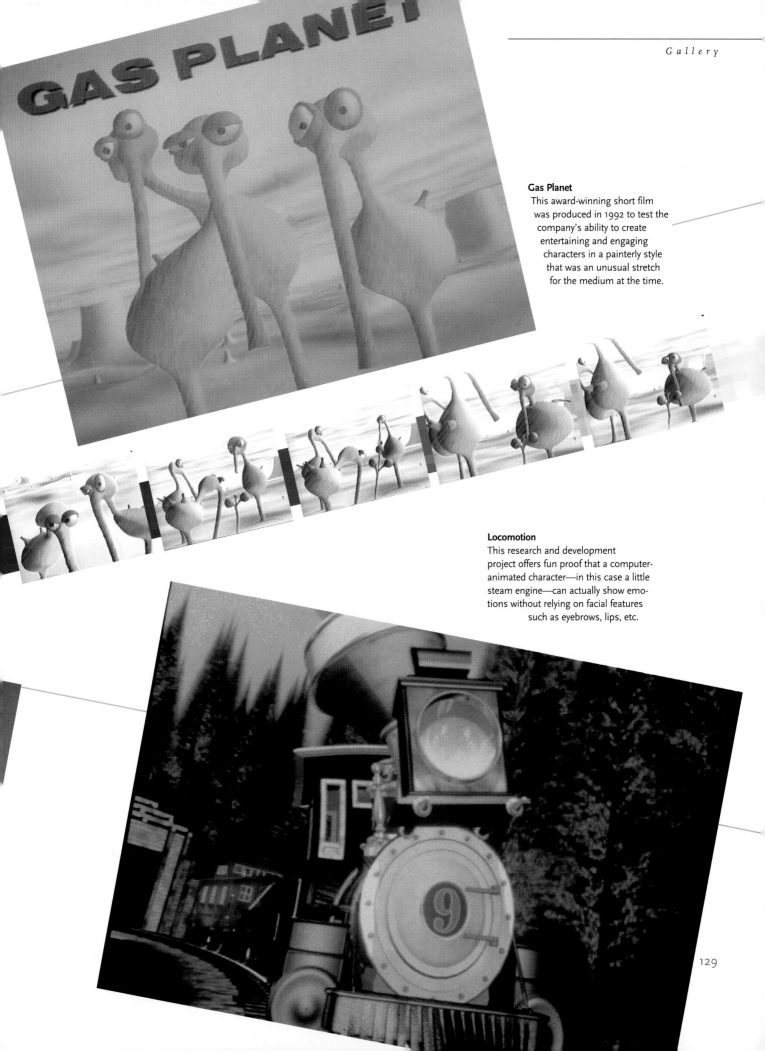

Gas Planet
This award-winning short film was produced in 1992 to test the company's ability to create entertaining and engaging characters in a painterly style that was an unusual stretch for the medium at the time.

Locomotion
This research and development project offers fun proof that a computer-animated character—in this case a little steam engine—can actually show emotions without relying on facial features such as eyebrows, lips, etc.

The Amazing
Means to the end

One of the first stages was developing models that Landreth could actually use to animate.

When animator Chris Landreth was hired by Toronto-based software development firm Alias/Wavefront, he was given an unusual assignment—to test the latest version of the company's PowerAnimator software and to prove that the program's new tool set could be used to create something really substantial. To meet this challenge, Landreth produced *the end*, a six-minute animated short that includes every bell and whistle in the PowerAnimator package, yet also works as a piece of art. In fact, in 1996, it was nominated for an Academy Award.

For *the end*, Landreth decided to poke some good-natured fun at both his friends and his own early work. The film opens on two odd, wiry, humanoids dancing on a surrealistic stage. During their pretentious performance they comment on "semiotics" and "transfiguration," nonsensical statements that Landreth culled from modern art reviews.

Windlight's Joan Staveley, a former modern dancer, drafted professional performers Wynn Fricke and Bob Zehrer for the motion capture session.

As the performance continues, the pair begin a dialogue by repeating the unusual phrase, "Speak to me now, bad kangaroo." Landreth's use of this wacky word string is one of several homages to revolutionary work in the field. The phrase was developed as a test for lip-synching animations at the University of Calgary. As the dancers continue their performance, a pair of flying hands enters from upstage and flutters between them—a salute to animator Joan Staveley, the flying hands come from *Wanting for Bridge*, a popular expressionist short.

Just when it seems that *the end* will be nothing but unintelligible bits and pieces of fantastic phrases and motion, the characters stop. They look at each other and question what they are supposed to do next. A voice is heard, the voice of Landreth explaining that they are simply animations that he has created to enter in a film festival.

To produce the futuristic, science-fiction look of *the end* Landreth knew he could not rely on traditional forms of animation. "The characters in this short don't look real," admits Landreth, "But I felt it was important for them to have real, very human movements. I didn't want their gestures to be cartooned or stylized. I wanted them to display motion that was uncannily human. But the only way to get that sort of look was to use motion capture as a template for my animation." To coordinate the intricacies of a motion capture shoot, Landreth turned to the Minneapolis-based animation house, Windlight Studios, the company that wrote the Motion Capture tool for the PowerAnimator software package.

The motion capture set-up at Windlight is magnetic, not optical, so dancers Wynn Fricke and Bob Zehrer wore Ascension Technology's "Flock of Birds" suit—a spiderweb of straps that covers the major anatomical features of the body and digitally records movement through a cable system linked to computers located on the motion capture set. To keep the cable system out of the dancers' way, a grip had to learn to literally dance along with the performers. Only one data set could be collected at a time, so as each dancer wore the suit—the other accompanied: The challenge came in the switch-off, when both dancers had to repeat their previous performance exactly.

As data was collected from each shot, it was interpreted by the Windlight PowerAnimator tool called MotionSampler. This tool applied the incoming movement data to joints of the digital character models created by Landreth. If, for instance, Fricke moved her elbow, her digital character model moved in perfect mirror image.

The lithe look of both Fricke and Zehrer was similar to that of the character models Landreth had constructed.

Although untrained as actors, the two took well to the wacky, expressionistic dialogue, quickly making it their own.

A preliminary sketch that led to the design of the characters.

Frame 38 02:52

Action: Woman continues to come forward.

Music: Building soundtrack, gradually swelling to emphasize the Woman's anthematic speech.

Woman: "...and not only do I have memory of my thoughts, I have AWARENESS of my memory of those thoughts. If anything, I am creating YOU. You had no choice but to create this animation, OK?...

Frame 40 03:04

Action: Hand holding pencil moves in front of the frozen image of the Woman's face.

Sound: Pencil scribbling noises.

Voice (now the Animator): "This piece is revolutionary...Yeah, uh–huh...

Frame 40 03:04

Action: Hand holding pencil moves in front of the frozen image of the Woman's face.

Sound: Pencil scribbling noises.

Voice (now the Animator): "This piece is revolutionary...Yeah, uh–huh...

The system ran so fast that Landreth was able to give feedback to his artists in much the same way a live-action director might. Seconds after each shot was completed he walked to the computer monitor, watched the application of the movement to his stripped-down polygonal models, and then gave directions concerning movement and timing to his artists before shooting the next take.

Says Landreth, "It took us a day to shoot the piece and we had a hell of a lot of fun. Even with all this complex machinery, we ran into very few glitches. In fact, the only real problem we had was shooting the sequence with Joan's hands. In the scene, the characters point at the flying hand-bird. So, to give the dancers a reference point, we tacked up a huge piece of construction paper on the back wall and painted on the trajectory that the hands would take. The problem was it kept sagging throughout the day, so the movement didn't match my animation."

After the shoot, Landreth returned to his home office at Alias/Wavefront and began the arduous task of cleaning up the motion capture data. As is typical with any motion capture shoot, the information collected was full of digital "noise" that included holes, or drop-outs in the data, and spikes that made portions unusable. After a clean version of the data was created, Landreth went back through each frame and enhanced the movement, animating it to his liking. "The thing to remember about motion capture is that it is not the end result," says Landreth. "It is just a base from

Several endings come to mind, but are quickly discarded . . .

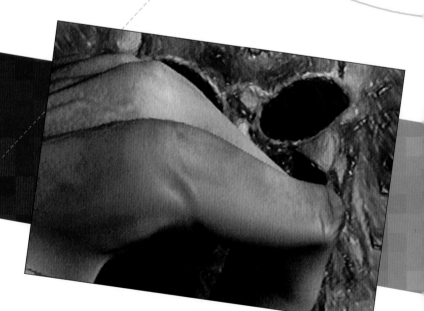

. . . for the ultimate ending in which the animator realizes that he is a work of his own fiction . . .

132

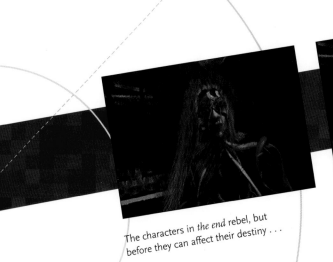

The characters in *the end* rebel, but before they can affect their destiny . . .

. . . the film changes locales, focusing on an animated version of Landreth working at his desk . . .

. . . storyboarding the scene that the characters were just in. As he continues to draw, he tries to decide on an end for the short.

which to begin your animation. After the shoot, I still had months of work ahead of me." Not only did Landreth have to make the motion capture his own by manipulating the data, he had to animate the characters' hands and faces. Even though the characters' hands were really anemone-like tendrils, he found their animation fairly straightforward compared to the characters' facial expressions. Says Landreth, "Nobody really knows what tendrils look or behave like, but everyone knows the human face. To make the characters' faces look believable required an extensive amount of time in the modeling and animation phase."

In order to produce the look of human speech, he gave each character thirteen facial controls or muscles. By combining these controls in various patterns, he built key frames that represented the extreme

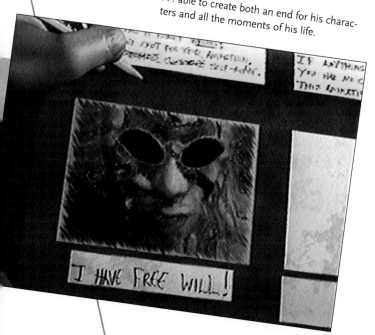

. . . able to create both an end for his characters and all the moments of his life.

positions of the mouth, cheeks, and eyebrows of the human face as it moves to create speech. Then using PowerAnimator's Shapeshifter tool, he blended these key poses to create believable movement.

Following his mission statement—to test every tool in the PowerAnimator set—Landreth next worked on the composition of his character's hair. "Because it is such a complex surface, hair is very difficult to create digitally," explains Landreth. "In fact, hair is so complicated that it has actually been the topic of research papers for the last ten years. The problem is that if you try to represent it the way you do other objects, you would have to build 50,000 flexible, bendable models. Complexity of that level is simply impossible to render. The only solution is a shortcut."

Landreth's shortcut involved the use of a particle system in PowerAnimator called "CompuHair." Essentially the tool enabled Landreth to apply similar qualities to thousands of particles at once. To build hair, he stretched out a single particle and then attached another stretched-out particle to its end, repeating the process until he had the look of a strand of hair. Once a basic model of a strand was obtained, the computer simply replicated the process until an entire head of hair was created. To add motion or body to the hair, Landreth instructed the computer to apply natural forces to the particle group—so that it appears to blow in the wind and then settle down as gravity takes hold. In all, Landreth created nine different types of hair which range from the frighteningly realistic to the utterly absurd.

Landreth's software test was rounded out by creating some gratuitous special effects that he admits he added simply "because he could." Using the Digital OptiF/X tool he produced an explosion, complete with smoke, a haloing effect and lens flares.

About the Artists

KAREN DUFILHO
TONY DEROSE

Pixar once again has a team dedicated to making one new short a year. Led by producer Karen Dufilho, the new team is hard at work on *Geri's Game*, the story of an old man who plays a very "mean" game of chess. Says Dufilho, "Just like the old days we're focusing on story and on pushing the technical envelope. For this film we're working on the dynamics of Geri's jacket and his skin."

A member of the "Studio Tools Group," Tony DeRose is one of the technicians in charge of these two critical areas. Says DeRose, "One of the early challenges with the jacket was learning something about tailoring. We built our first model without paying attention to what makes a well-cut jacket a well-cut jacket—things like enough room in the shoulders or under the armpits. So for our second model we had to come up with our own digital tailoring techniques."

For the facial animation work DeRose is expanding on the controls used to build the faces of Buzz and Woody. "We're trying to get more broad-reaching effects. For instance, if a jaw opens then some motion will occur in all parts of the face—the ear lobes will move just a bit, the eyebrows, the bags under the eyes. These additions keep the human face from looking stiff."

CHARLOTTE DAVIES

Charlotte (Char) Davies studied visual arts at Bennington College, Vermont, and the University of Victoria, British Columbia, receiving a bachelor's degree of fine arts in 1978. A painter and filmmaker, she began working with 3-D digital media when she joined Softimage in 1988, helping to build the company and sitting on its Board of Directors until 1994. The 3-D still images she made with Softimage software between 1990 and 1993 (known as the "Interior Body Series") were exhibited worldwide and won numerous awards. As director of visual research for Softimage, she created *Osmose* and is now working on a second immersive environment.

BETSY DE FRIES
JERRY VAN DE BEEK

The company name Little Fluffy Clouds was, according to Betsy De Fries, "shamelessly stolen from a song by the English band Orb." The boutique opened its doors in 1996, setting up shop in a Spanish-style hacienda at San Francisco's Pier 29, a landmark left over from the World's Fair of 1939. Little Fluffy Clouds specializes in computer animation, special effects, and new media. When De Fries and partner Jerry van de Beek aren't doing contract work, they focus their time on completing an independent film called *Go Fish*.

More than anything in the world, Raman Hui wanted to be a computer animator. His dream came true when he signed on at Pacific Data Images in San Francisco.

ANDREW "SPANKY" GRANT

Like all the animators on *ReBoot*™, Andrew "Spanky" Grant has learned more about his craft working on this series than all of his other experiences in animation, combined. Says Grant, "I'd spent four years animating in commercials before coming here, so I pretty much thought I knew what I was doing. Because of that I asked for a hard scene, something with a lot of action to it. I was awarded a two and a half minute swordfight between Bob and a skeleton on the episode 'The Quick and the Fed.' Now I've always been a big Harreyhusen fan, so it was fun to rent all the old Sinbad movies and brush up on the skeleton fights. But the scene was the hardest thing I'd ever done. It was a real turning point for me. When I look at that scene now, I see how I'd do it differently; how raw I was, but . . . also . . . how far I've come."

RAMAN HUI

As far back as he can remember Raman Hui had a yen for animation. Unfortunately opportunities for learning and plying the craft were limited in his Hong Kong homeland. When it came time to decide on a college major, he had to settle for a degree in graphic design. However, he found his salvation hidden away in a back room of the art department—an unused Rostrum camera the holy grail for an aspiring animator. Hui played with the camera as much as possible, learning the basics of animation on his own. After graduation, not knowing where to apply for animation work, he was forced to settle—this time for work as an artist with an advertising firm. "I was pretty happy there, I guess," says Hui. "Then a classmate asked me to go along on a visit to one of the few animation studios in the city. I got a job there and it changed my life."

At Quantum Studios, a commercial production house, Hui soaked up every ounce of knowledge and, in turn, produced some phenomenal work. But life at Quantum wasn't easy, in fact sometimes it seemed like all he did was pay karmic tuition in exchange for learning his beloved art.

"The commercial business in Hong Kong was crazy," laughs the good-natured Hui. "I remember working round the clock for seven days and seven nights on one project. We didn't go home; we just sort of napped at the studio. It was really insane but also good because it pushed me and my work. But, I have to admit, after four years, I needed a break."

By this time rumors of a new trend called computer animation had reached Quantum. Always the inquisitive type, Hui was intrigued by the new tool and decided to learn more about it before it "started to scare him."

He took a summer leave of absence and moved to Toronto, Canada, the home of world renowned Sheridan College—an institute with a "real" animation department dedicated to cutting-edge techniques. After a few months of training, Hui's considerable talents shined through. His professors urged him to apply for a job at a major computer animation house. The first company he applied to, Pacific Data Images in Northern California, offered him a job. The rest, as they say, is digital history.

IAN PEARSON

Many artists claim that their best ideas came to them in dreams, in rush hour traffic or in the shower. For the creator of, *ReBoot™*, British-born Ian Pearson, the great ideas of his career came at the local pub. Says Pearson, "Some of the best advice I've ever received I've gotten in pubs, including advice that led to the two turning points of my life."

Pearson began his career as an illustrator but moved into a civil engineering post after training on the computer. "Which," he admits, "I didn't like at all. What I did like was commercials. In fact, at the pub, I was a commercial bore. While everyone else was talking about soccer matches, I was rambling on about adverts. Finally, a friend turned to me and said, 'If you're so mad on commercials, why don't you do them?' And that's exactly what I did."

Pearson left his sleepy college town of Pyne and Wear and his partially completed degree in multimedia to pursue fame and fortune in the big city. "After that conversation in the pub, I decided to go to London. Everyone told me it was impossible to break into the commercial business there, but they were wrong. In my first week I got six job offers."

Pearson worked as a 2- and 3-D animator producing special effects at various post production companies. His most well-known work from that time was the computer animation he did on the ground-breaking Dire Straits music video, "Money For Nothing." Although the "Money For Nothing" production was, as Pearson puts it, "pretty much three weeks of sheer hell," it led to another interesting conversation at a local watering hole. "After we wrapped, me and Gavin Blair who also worked on the video were having a drink outside a pub and came up with the idea for *ReBoot™*." After that, Blair and Pearson worked on the idea whenever their schedules allowed—which, in the busy post-production world, was seldom, if ever.

The lack of time for *ReBoot™*, coupled with the nagging realization that his paying work did not reflect his artistic sense led Pearson to yet another turning point. Once again at a pub, he talked about life and the difficulties of "marching to the client's drum."

Says Pearson, "I was telling all this to a barmaid who asked me how, if I was really a creative person, I could survive doing somebody else's work? Her ques-

tion really got me. It kept me up all night; just ripped my soul apart. And that's when I decided to devote my life to *ReBoot™*."

Pearson brought on partners Phil Mitchell, Gavin Blair, and Christopher Brough and together they invested everything in the development of the world's first fully computer-generated television series. "After we had a pitch together, I departed for the United States and sat on the doorsteps of everybody in Hollywood until I finally sold the idea to ABC."

Once a deal was made, Pearson hunted for a likely location to set up shop. "England was too cost-prohibitive. We ended up in Vancouver, the home of our business partner, BLT Entertainment, due in part to all the tax breaks. We saved over one million dollars in hardware alone. Plus, we fell in love with the city."

That was 1993 and the rest, as they say, is history—history that even Pearson will agree makes a pretty good drinking story!

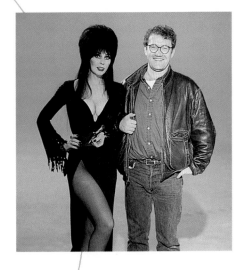

New Wave company head Ben Stassen poses with Elvira 'Mistress of the Dark' during a break from her green-screen shoot.

BEN STASSEN

After Ben Stassen, a native of Belgium, graduated from the University of Southern California's School of Cinema and Television, he directed and produced travel magazines for cable and home video. Later, his independent production *My Uncle's Legacy*, won him a Golden Globe nomination for Best Foreign Film in 1990. While working on his second feature, he discovered computer animation at the Brussels-based house, Little Big One. Stassen suggested the company make a simulator ride film as a showcase to garner international attention. That film, *Devils Mine Ride*, garnered more than just international kudos for the company, it launched Stassen into a career in the large format market. Now, as head of New Wave International, he produces six ride films a year and is planning to create a feature-length computer-animated movie for the IMAX format.

DREW TAKAHASHI

Chairman and CCO of (Colossal) Pictures, Drew Takahashi got his start in Hollywood working with likes of George Lucas and Francis Coppola as a member of the Korty Films staff. After working on films such as *American Graffiti* and *The Conversation,* he joined forces with fellow Korty staffer, Gary Gutierrez, to form (Colossal) Pictures.

The company name, which was meant as a bit of a joke since the duo actually started work in Takahashi's basement, stuck. In fact, more than sticking it became the basis for the company's sense of style—do anything as long as you do it big, wild and a bit . . . irreverent.

Acknowledgments

Thank you to the following individuals for digging through their archives, working with me to obtain clearances for copy and images and for making the whole process enjoyable: From Pixar—Ed Catmull, Katherine Singson, Joy Gibson; From New Wave International—Ben Stassen, Charlotte Huggins, Bob Mazza; From Industrial Light & Magic—Miles Perkins, Debra Amador; From NewLine Cinemas—Robin Zlatin, Travis Topa, John Smith; From Todd McFarlane Toys—Julia Simmons; The filmmakers of "Plug"—Jamie Waese, Meher Gourjian; From Mainframe—Helen Chapman, Michael Hofler, Mairi Welman; From (Colossal) Pictures—Jo-Carol Block, Hayes Raffle; From Little Fluffy Clouds—Betsy De Fries, Jerry van de Beek; From Click 3 West—Mark Richardson; From Medialab—Maia Tubiana; From K• Media Relations—Tara Kolla; From Softimage—Charlotte Davies; From MK Communication Resources—Heather Talbott; From Lamb & Company—Bob Spande, Pat Hunter, Larry Lamb; From Pacific Data Images—Raman Hui, Judy Conner; From Alias/Wavefront—Franca Miraglia; From the Coca-Cola company—Norman A. Mandel, Angela Cordon.

Thank you also to my husband, David Kelting, for putting up with and believing in me.

About the Author

Rita Street began her career in animation with a sales position at Expanded Entertainment, the film distribution company for independent animated shorts. Since then she has been both Editor and Publisher of *Animation Magazine* and written about traditional and computer animation for such publications as *Variety, Film & Video, Shoot* and *Cinefex*. Street founded the international organization, Women In Animation in 1993 and as president of the International Board, she is committed to helping others create or expand their careers in the art form. Street now works on the production side of animation in story development at Jim Keeshen Productions in Los Angeles. She is also co-authoring a book on the Unicef Animation Consortium Project.

Index